FCK OFF, CORONAVIRUS, I'M COLORING!

De-Stress With 50 Obnoxiously Fun Swear Word Coloring Pages

DARE YOU

STAMP CO.

A belligerent subset of
Cider Mill Press Book Publishers

CIDER MILL PRESS

BOOK PUBLISHERS

KENNEBUNKPORT, MAINE

13-Digit ISBN: 978-1-64643-044-4
10-Digit ISBN: 1-64643-044-1

This book may be ordered by mail from the publisher. Please include $5.99 for postage and handling.
Please support your local bookseller first!

Books published by Cider Mill Press Book Publishers are available at special discounts
for bulk purchases in the United States by corporations, institutions, and other organizations.
For more information, please contact the publisher.

Cider Mill Press Book Publishers
"Where good books are ready for press"
PO Box 454
12 Spring Street
Kennebunkport, Maine 04046

Visit us online!
cidermillpress.com

Typography: Fairytale, Festivo Letters No. 11, Archive Tilt, Satisfy, and Adobe Garamond Pro

Printed in China

9 10 11 12

IF you've gotten this far, then you're our kind of fucker! Or perhaps you're already a fan of our little Dare You Stamp Company because we've long been producing irreverent products that support voicing the rebellious chord in each of us.

Whether you've used our FU Stamp Kit on that denied insurance claim, or sent your egotistical ex one of our "You Suck" postcards, you know we firmly believe in free speech, free expression, and especially the inalienable right not to be F'd with when we're coloring, especially as we deal with this BS coronavirus!

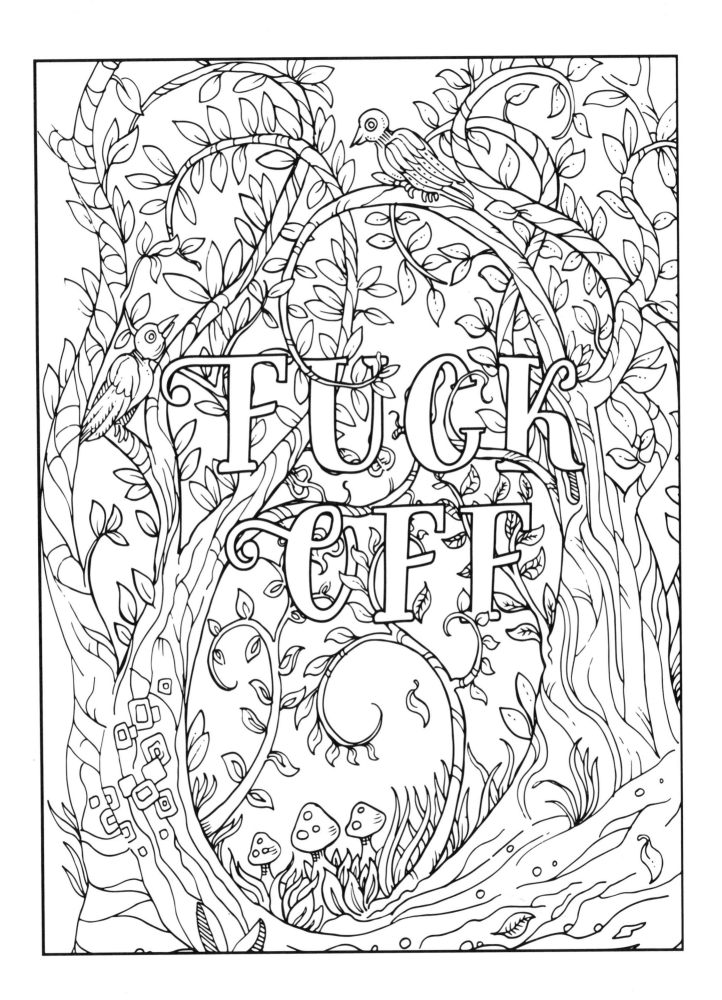

TABLE *of* CONTENTS

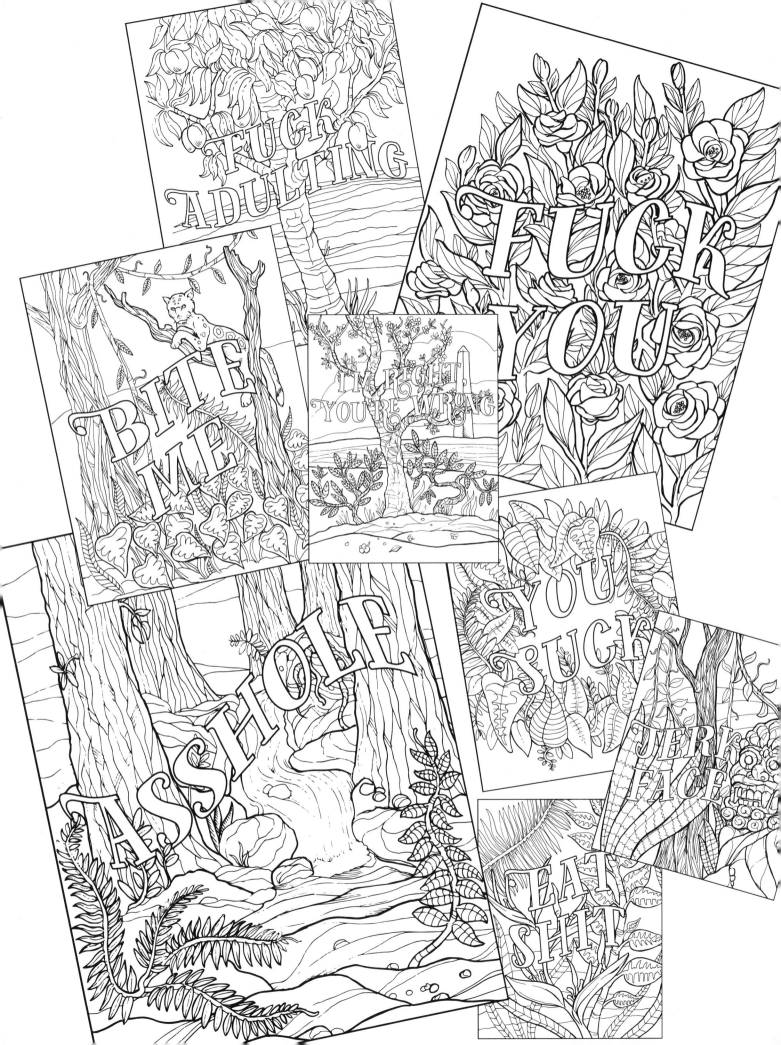

INTRODUCTION

Stressed out? Frustrated? Pissed off? We've got you covered… or, should I say, *colored*. We all know that the act of coloring unleashes some serious meditative power—putting colorful pen to intricately-designed paper has been calming us down since we were kiddos. So, why not get back to basics, return to what works, but add a little grown-up twist now that we're all adults here? Combine the calming act of coloring with the satisfaction of throwing around a good strong swear word, and feel your tension dissipate!

We've created swear-word coloring pages perfect for these strange, stuck-at-home days. So, rather than screaming "Fuck Off!" at the screen and those you live with take our approach to calming down—grab a marker, flip to any page, and let loose! Everyone else can just fuck off because, well, you're coloring!

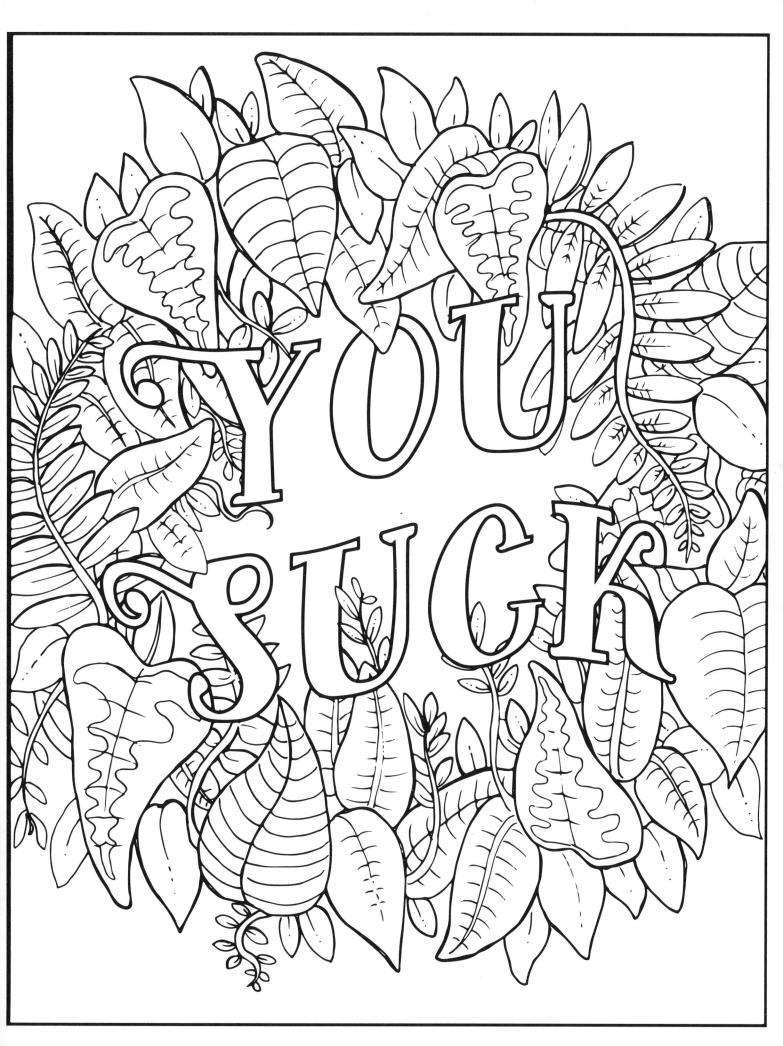

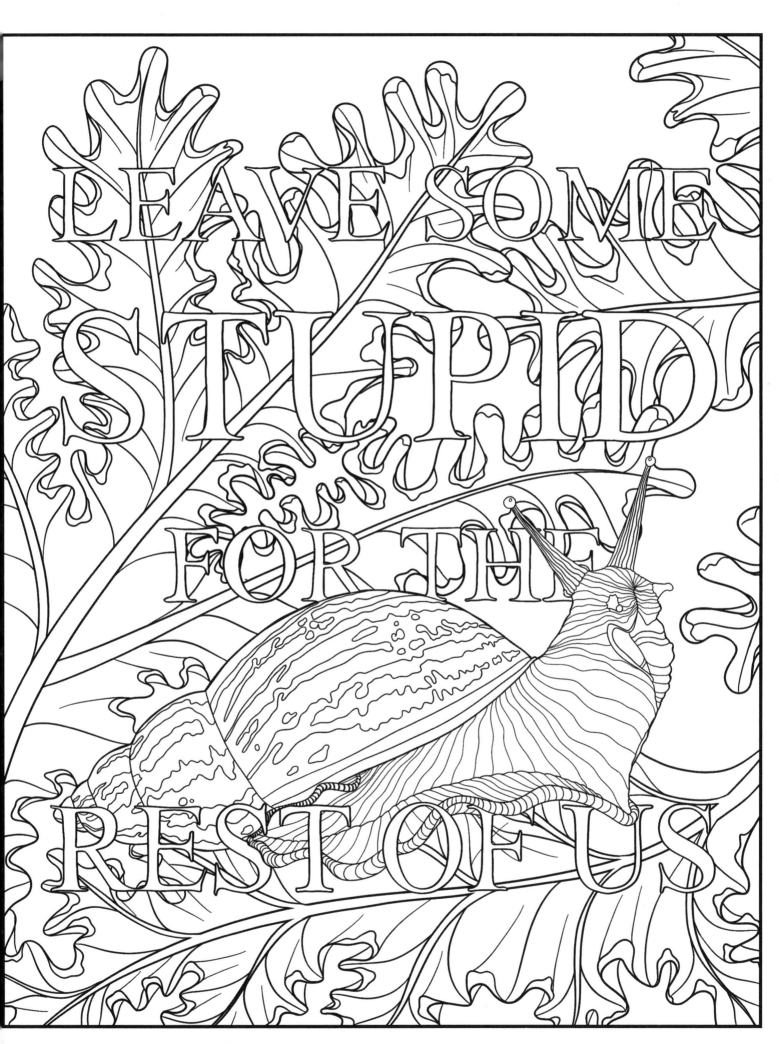

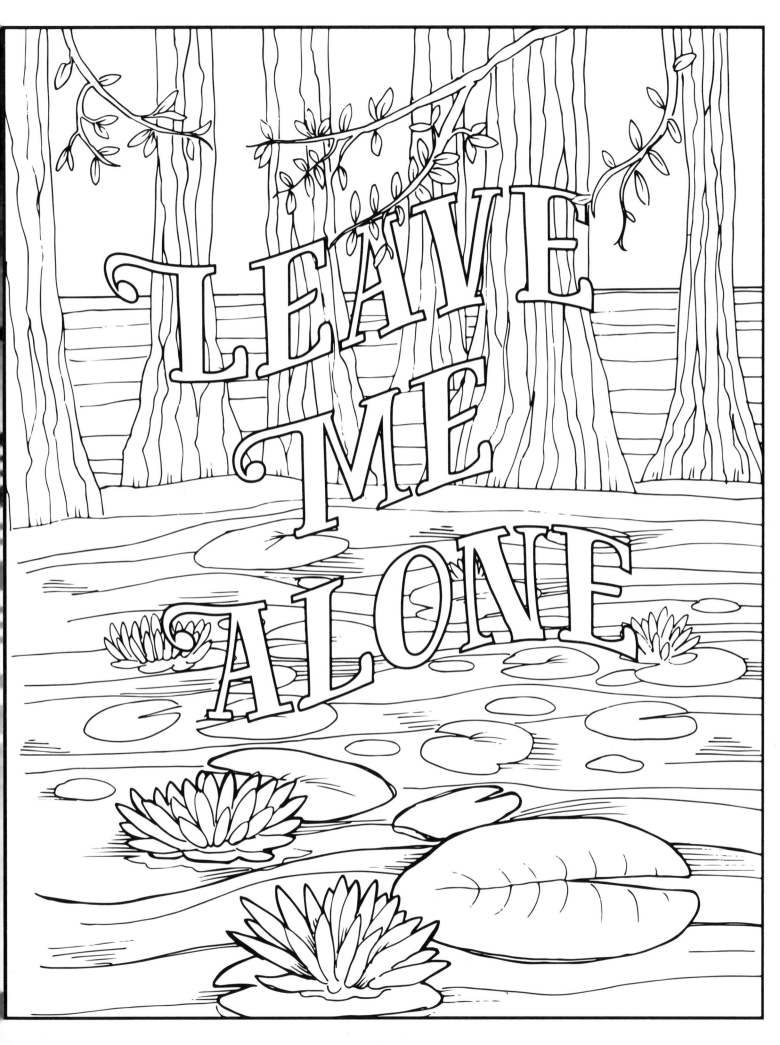

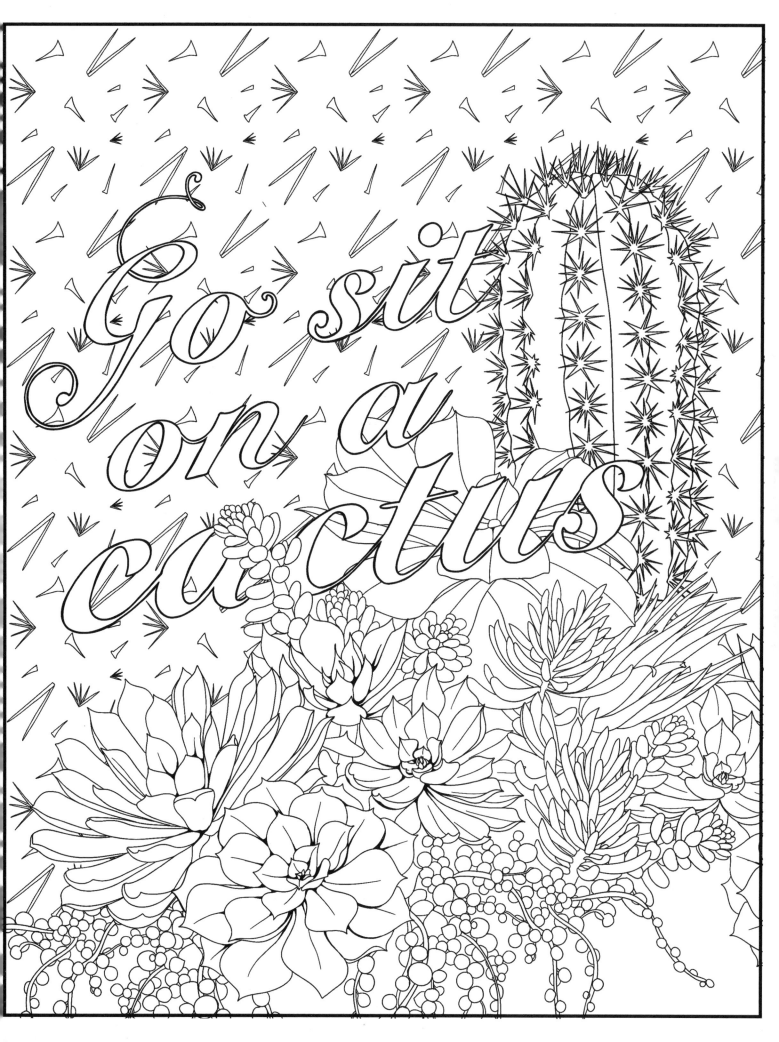

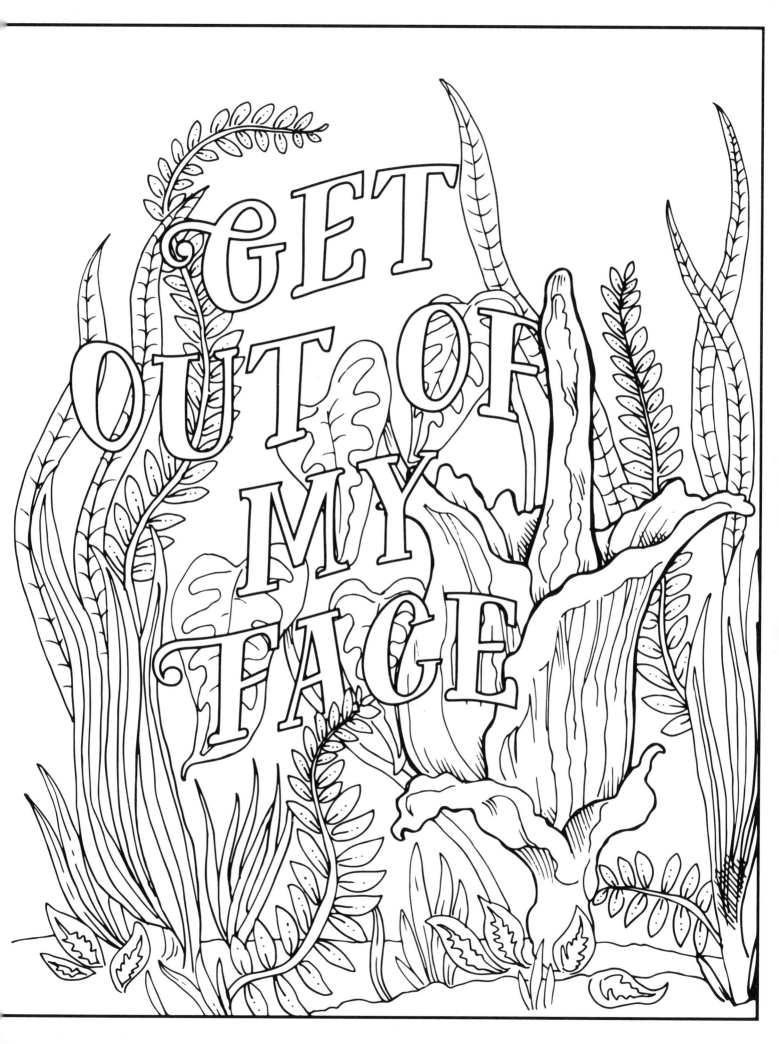

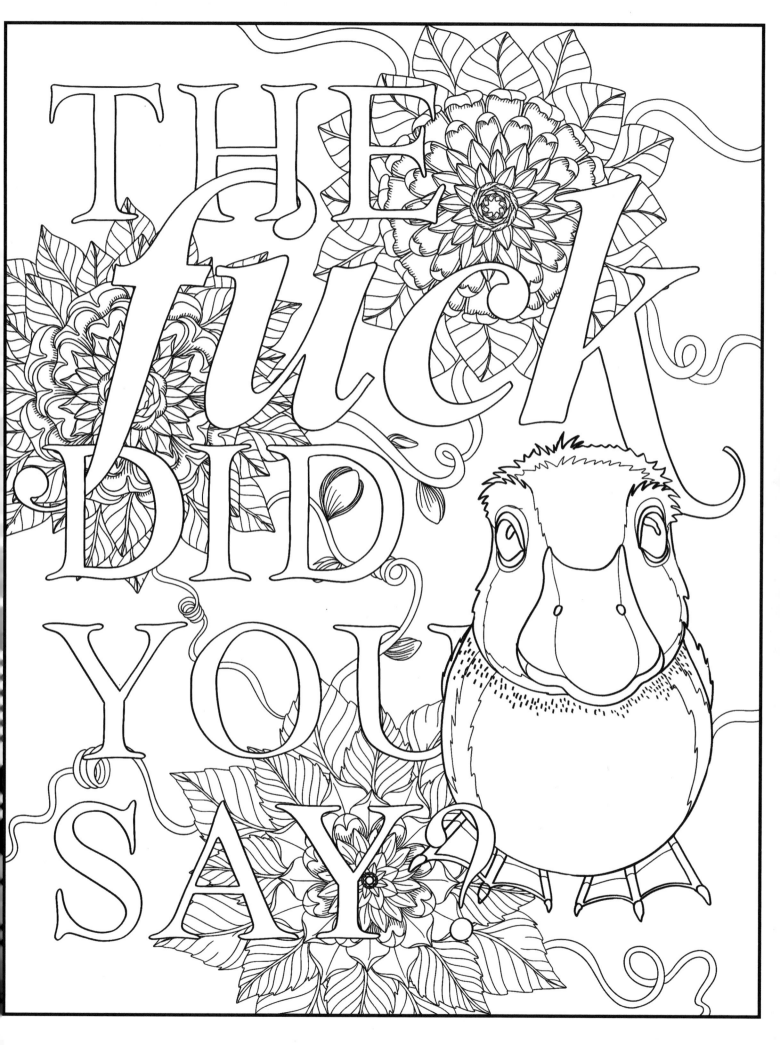

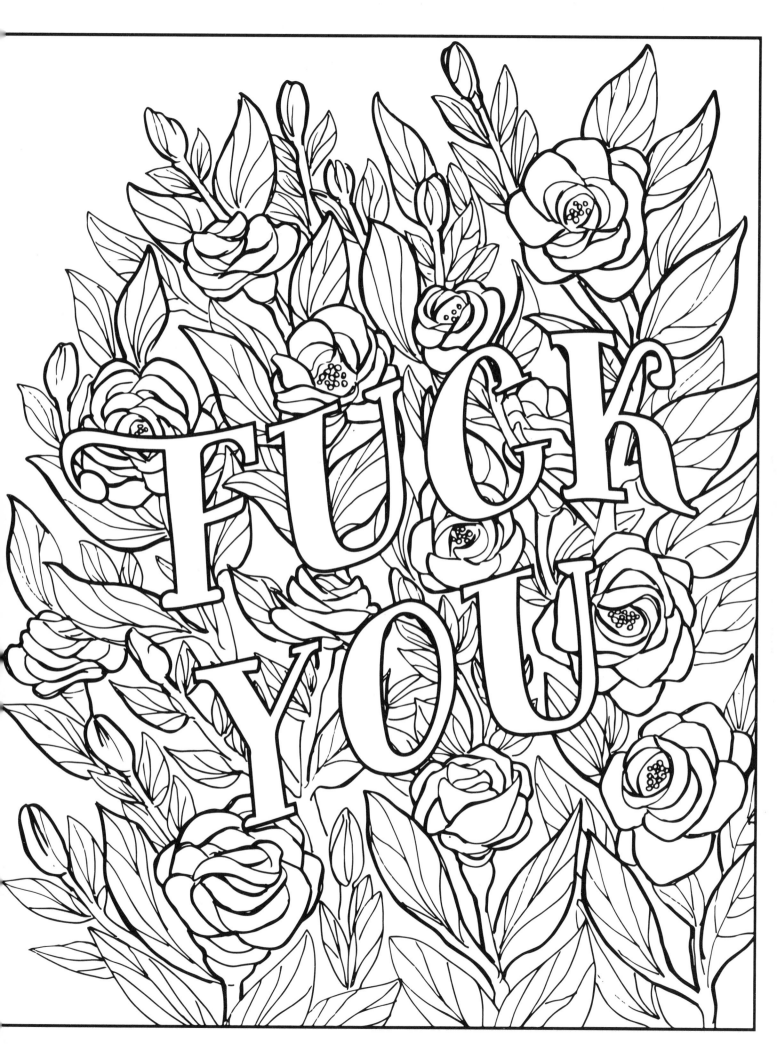

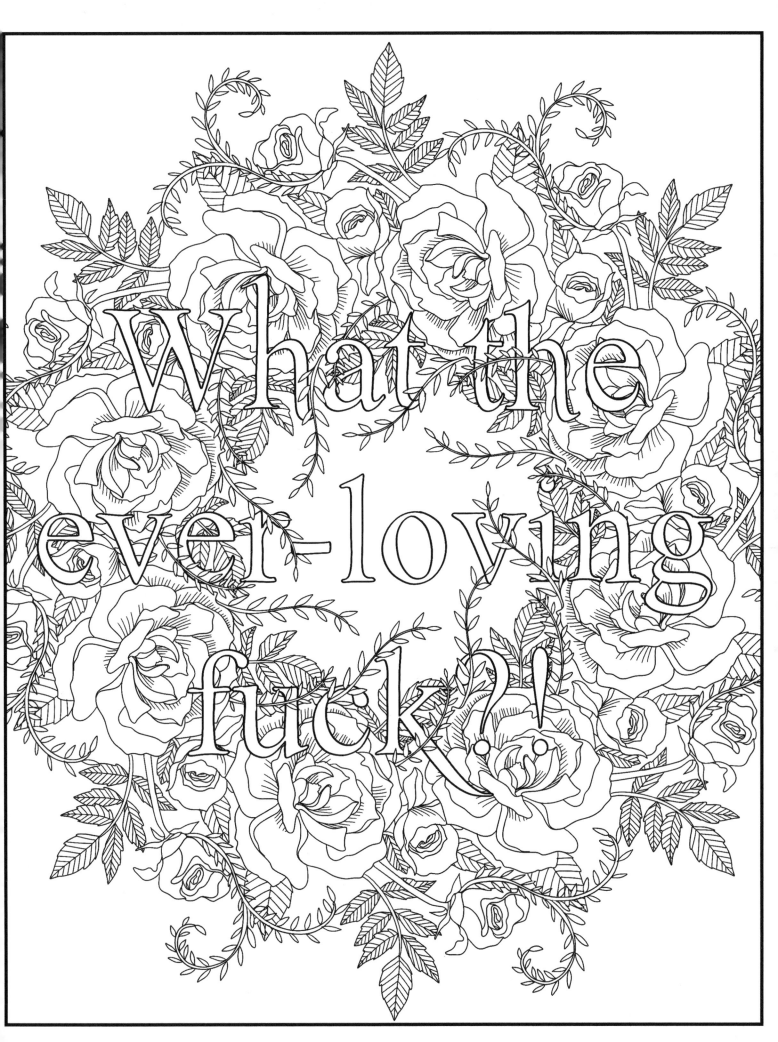

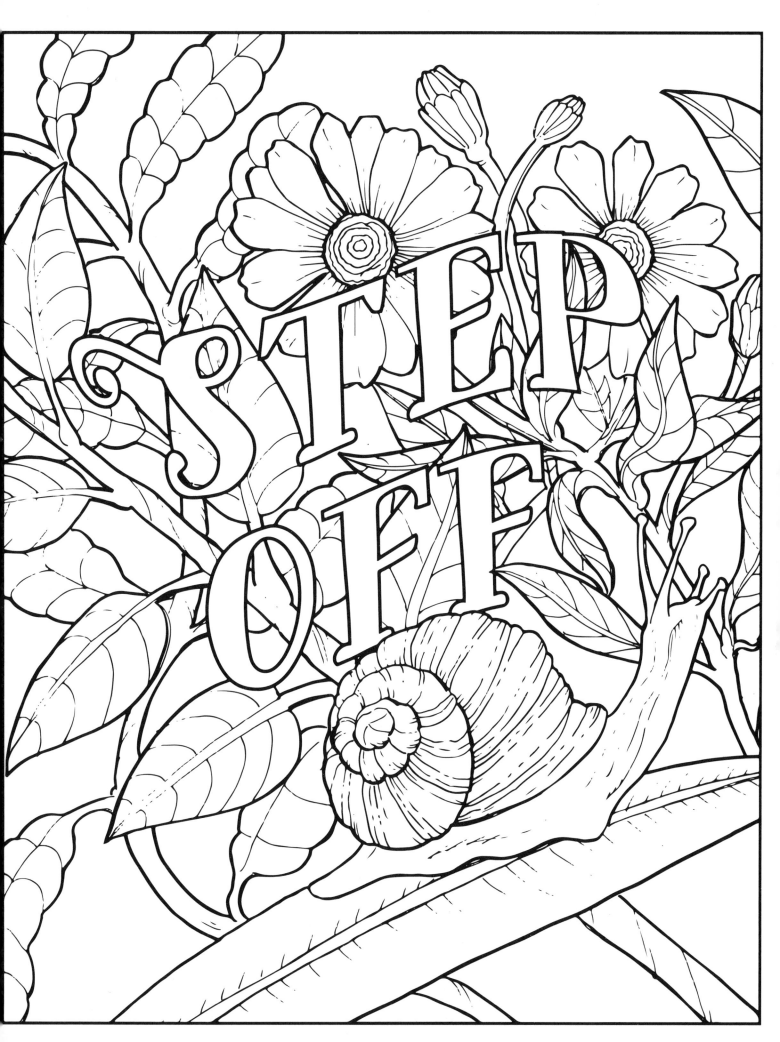

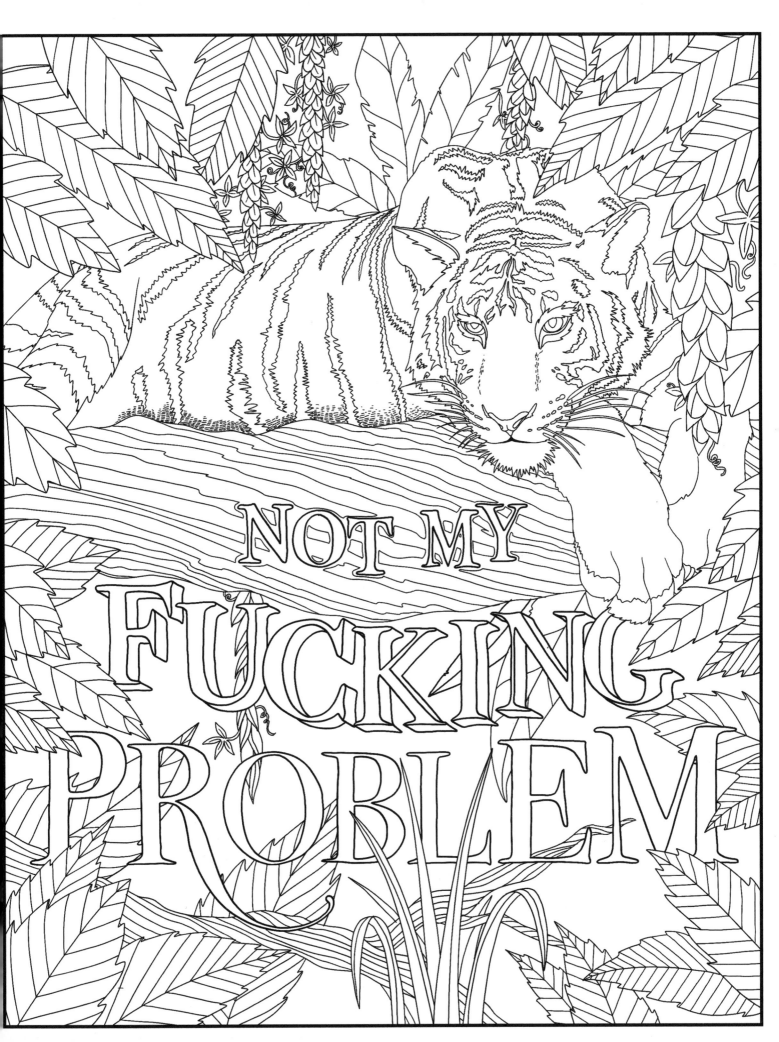

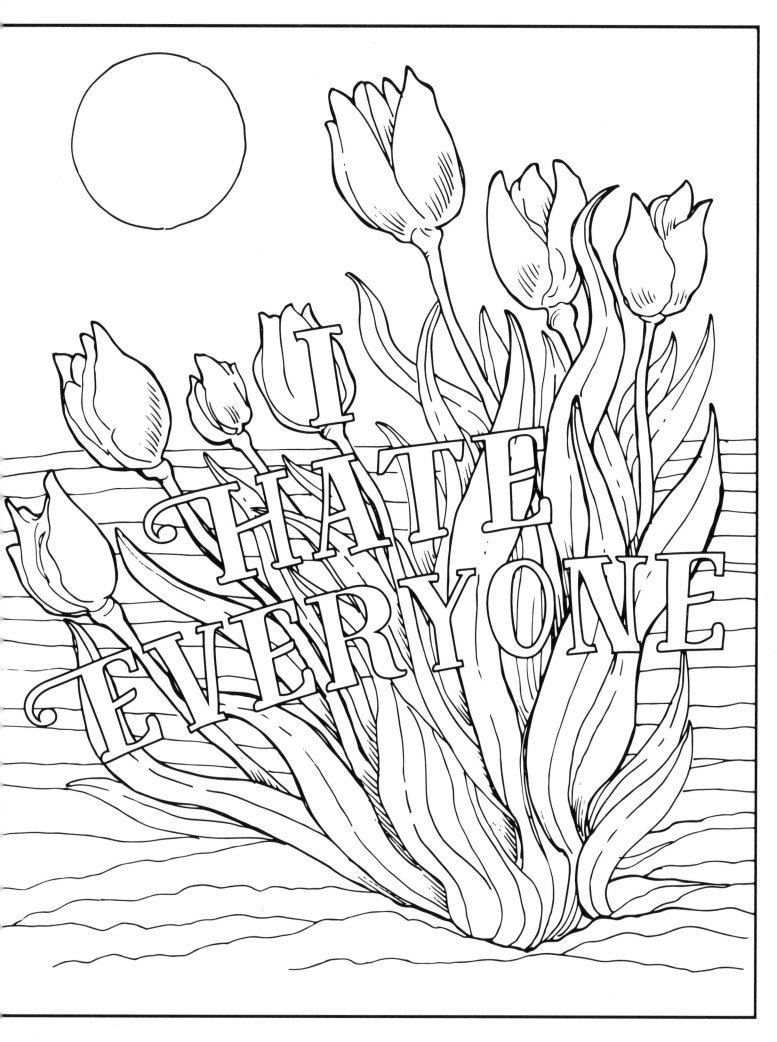

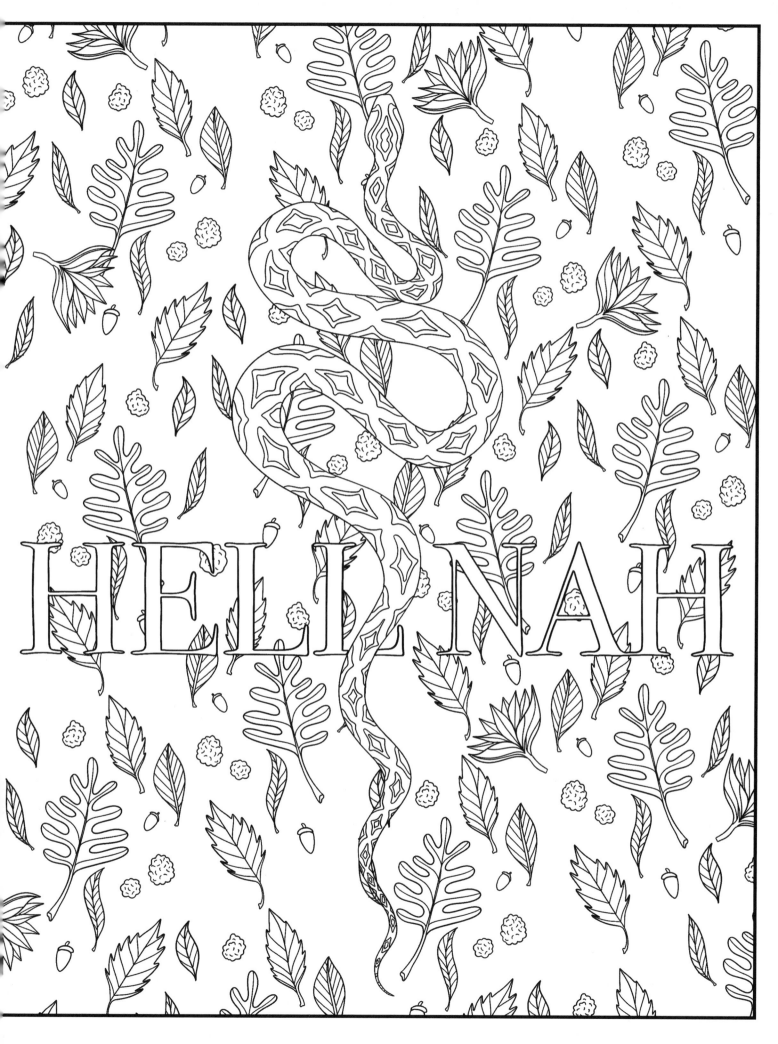

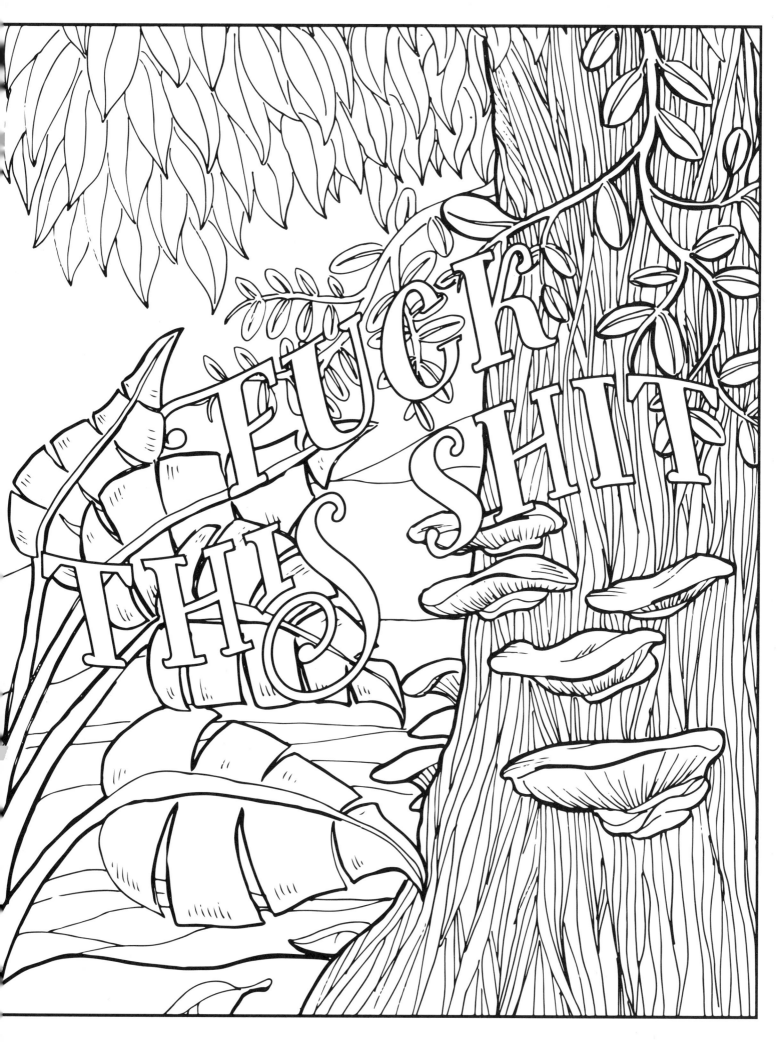

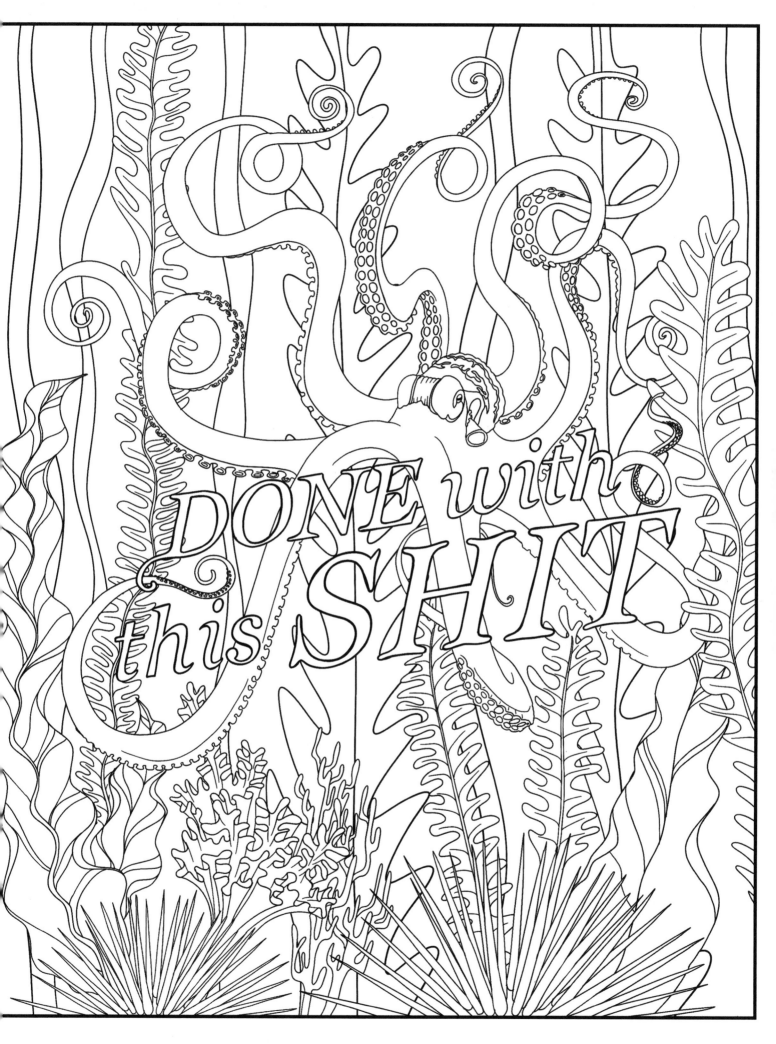

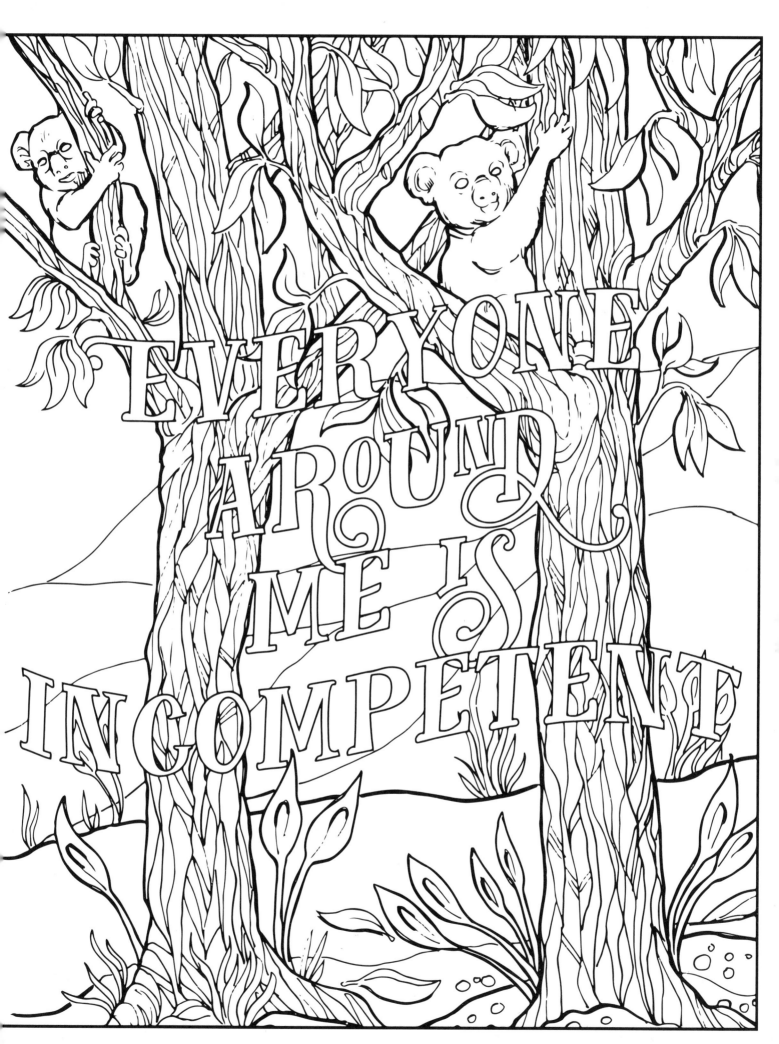

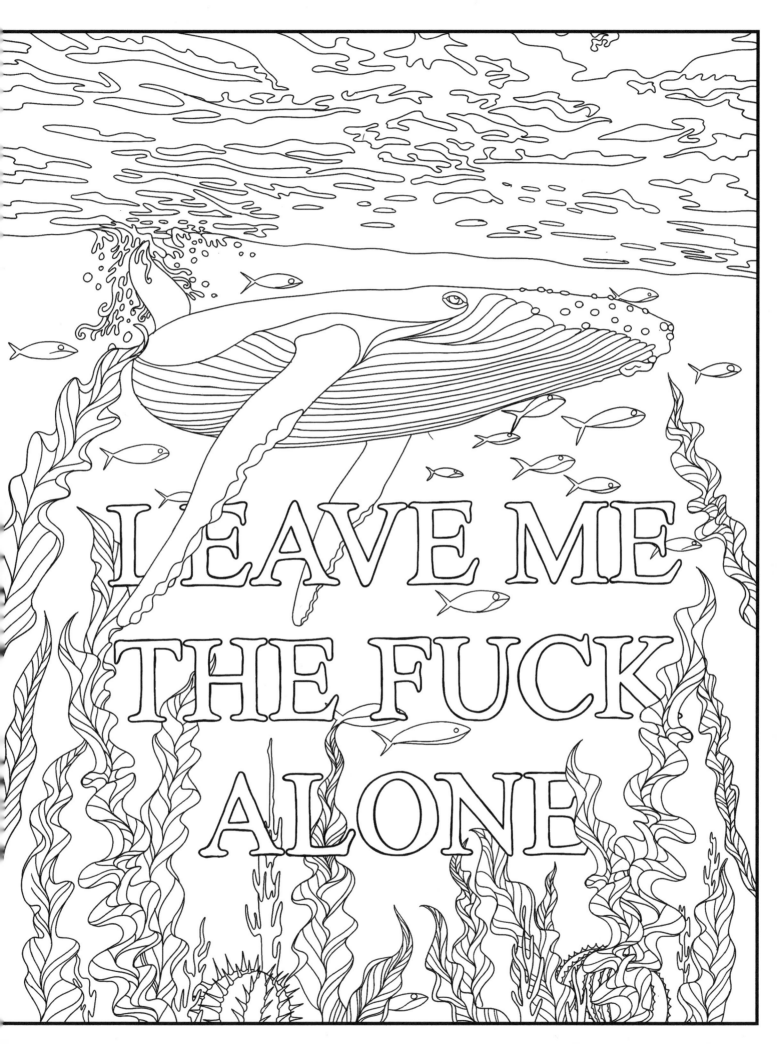

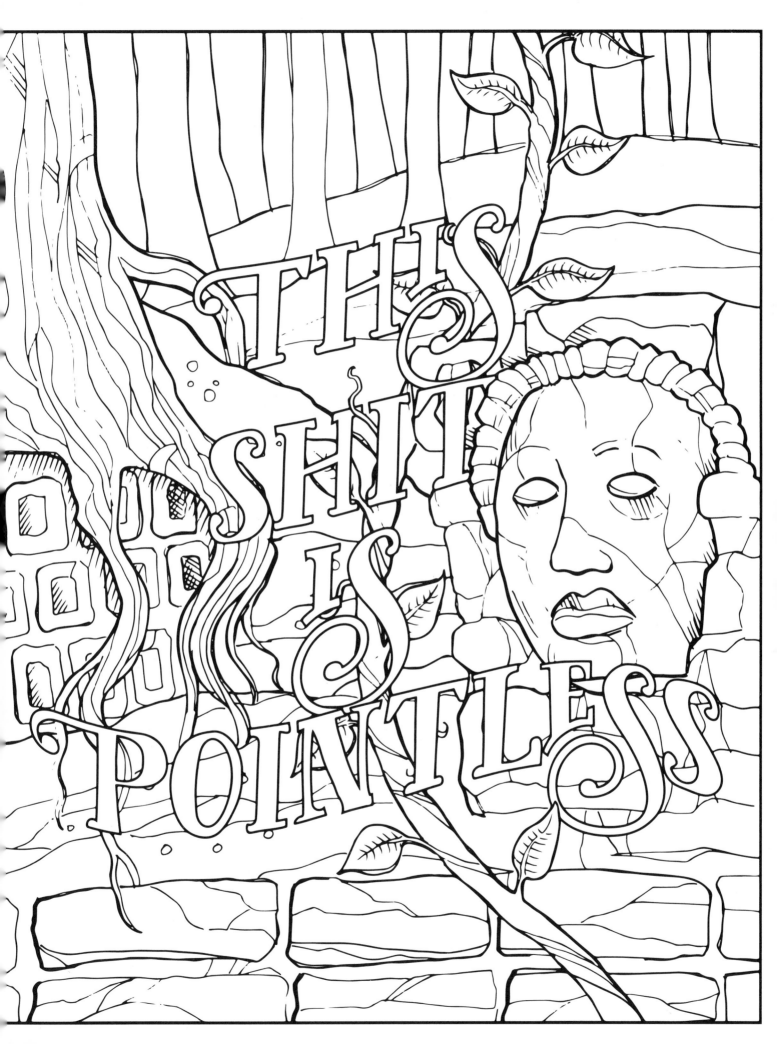

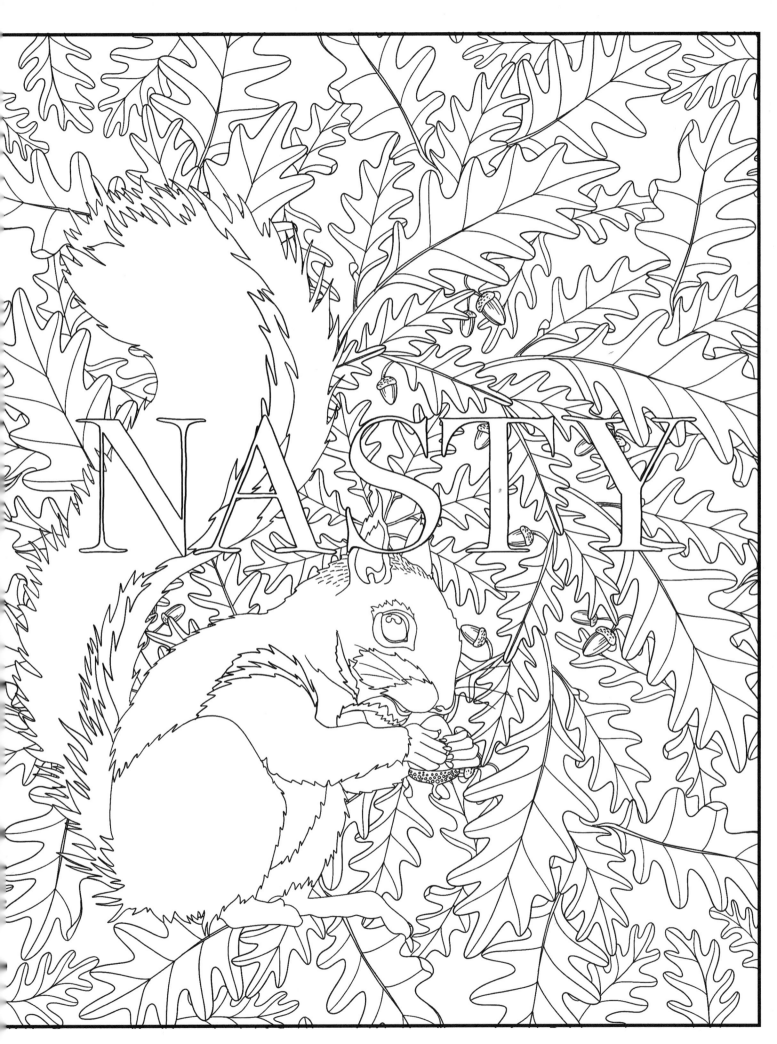

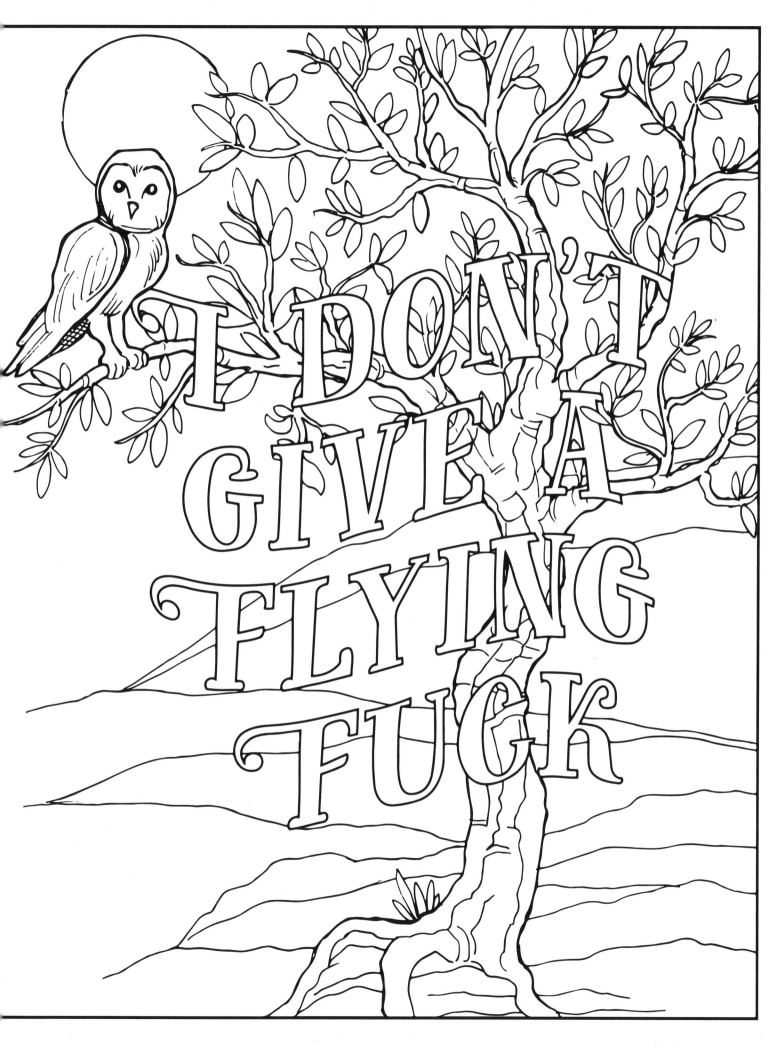

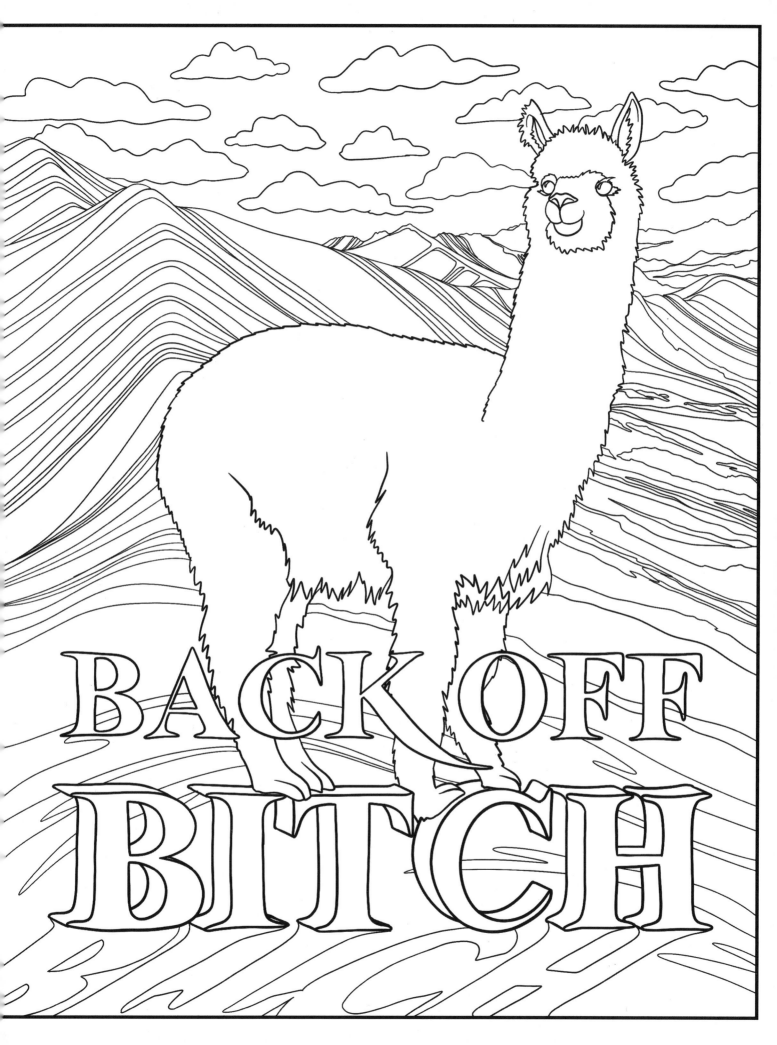

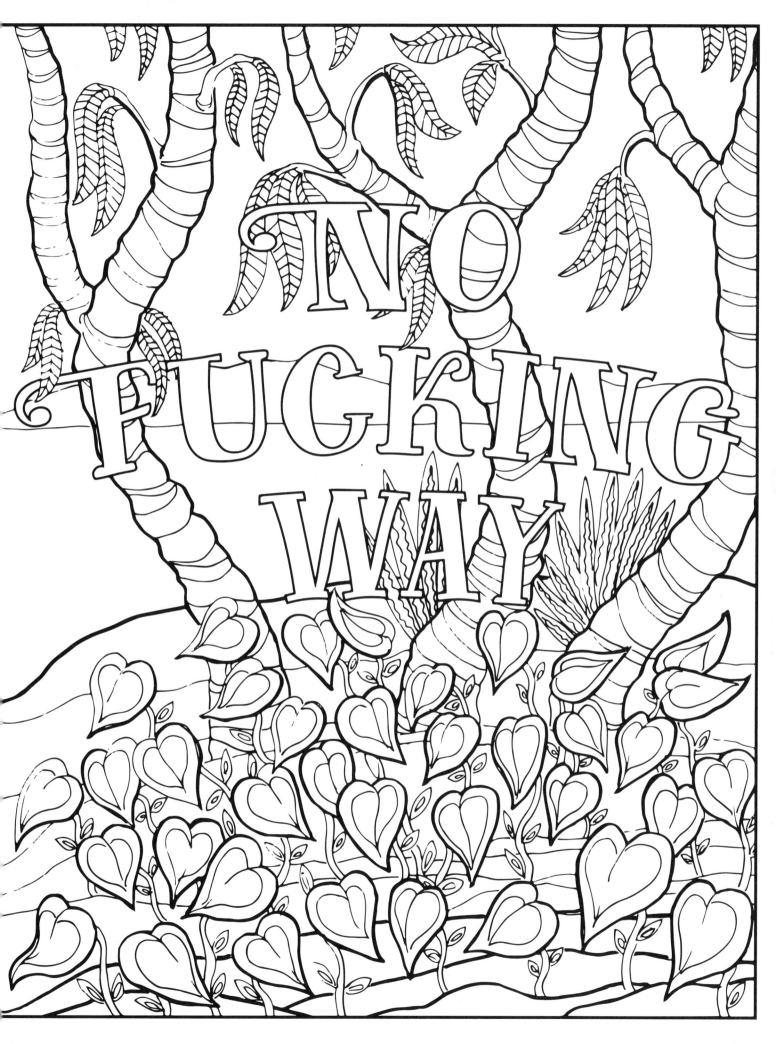

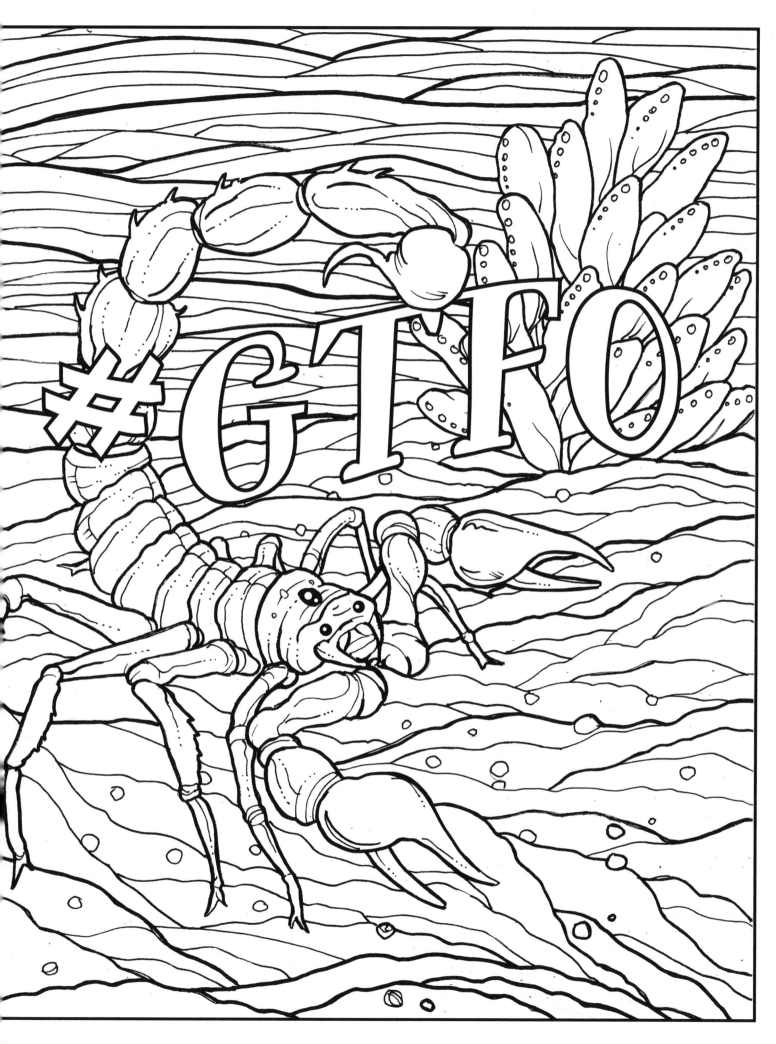

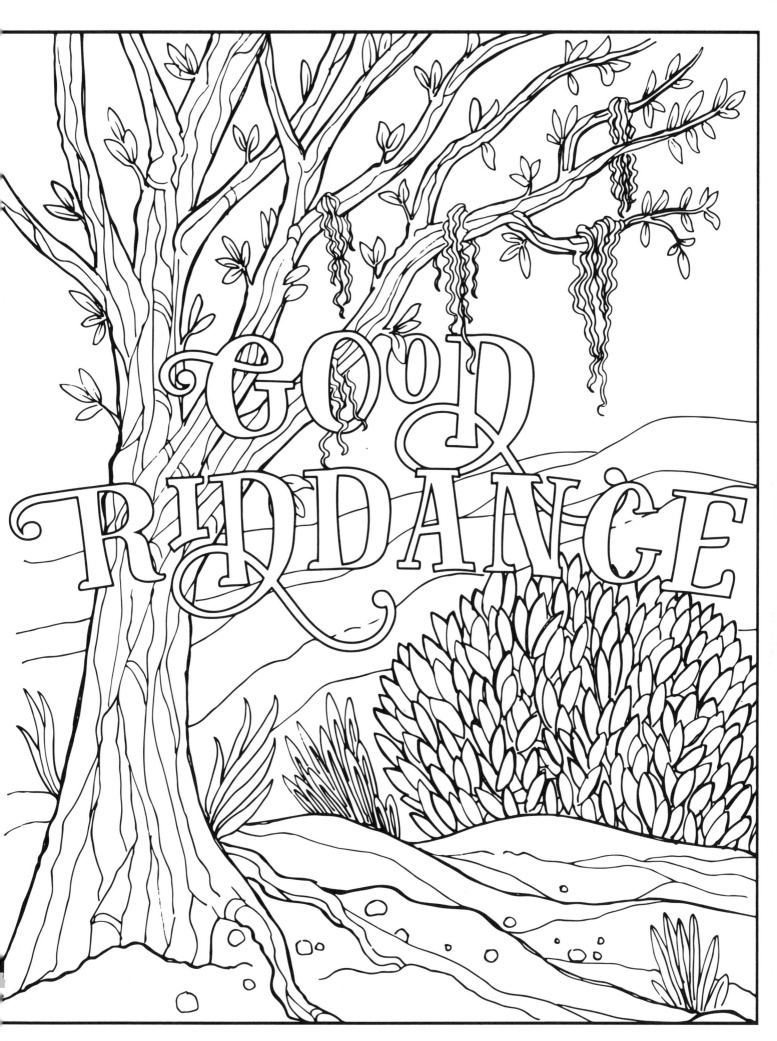

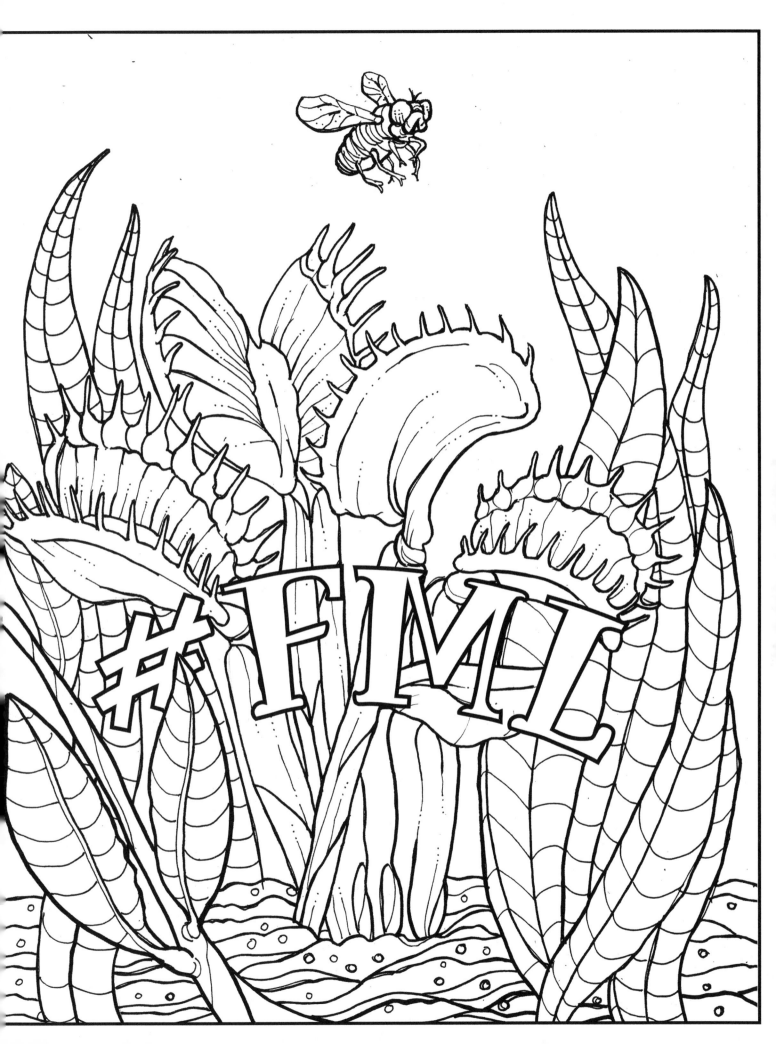

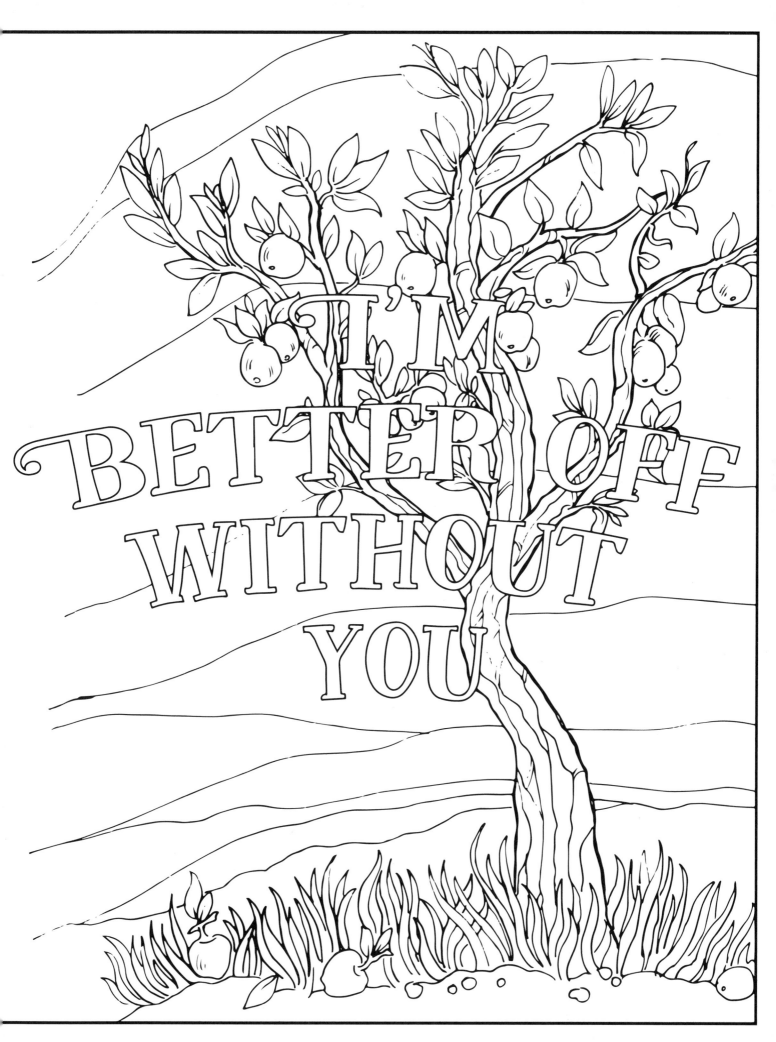

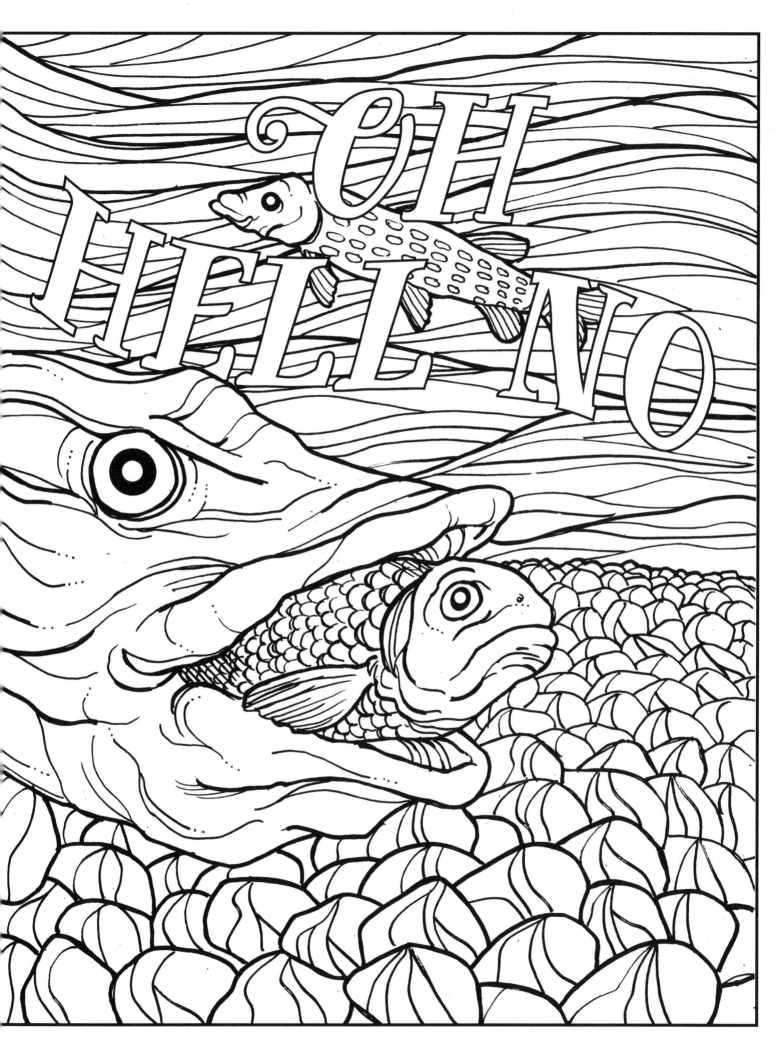

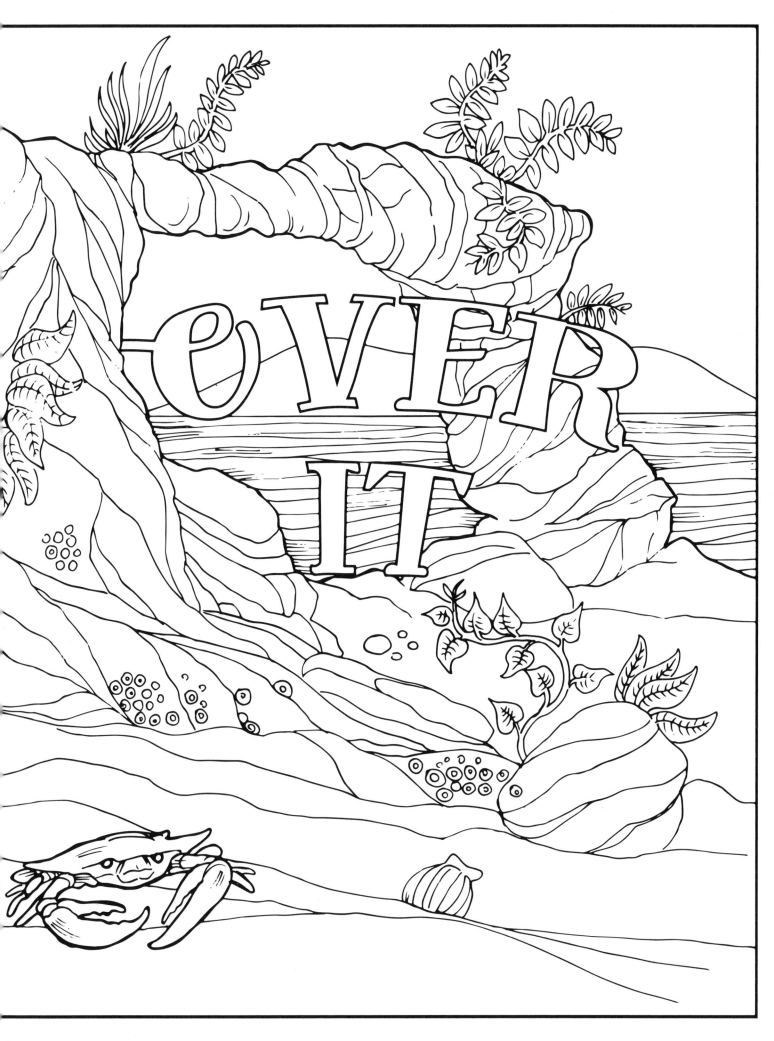

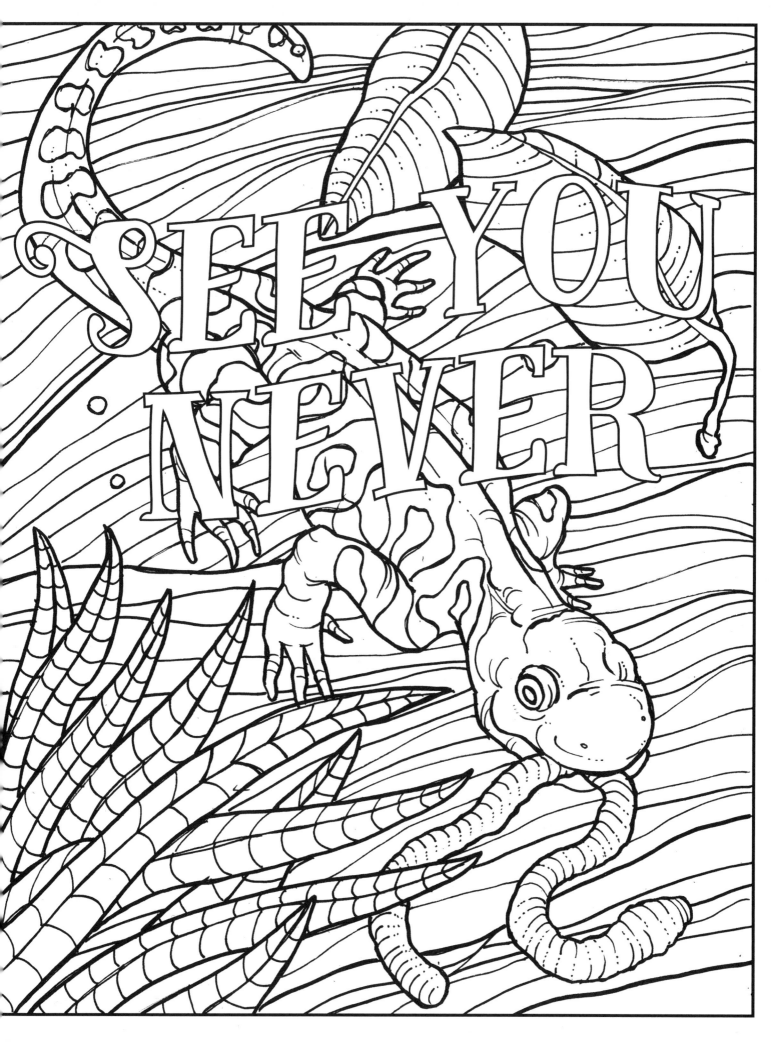

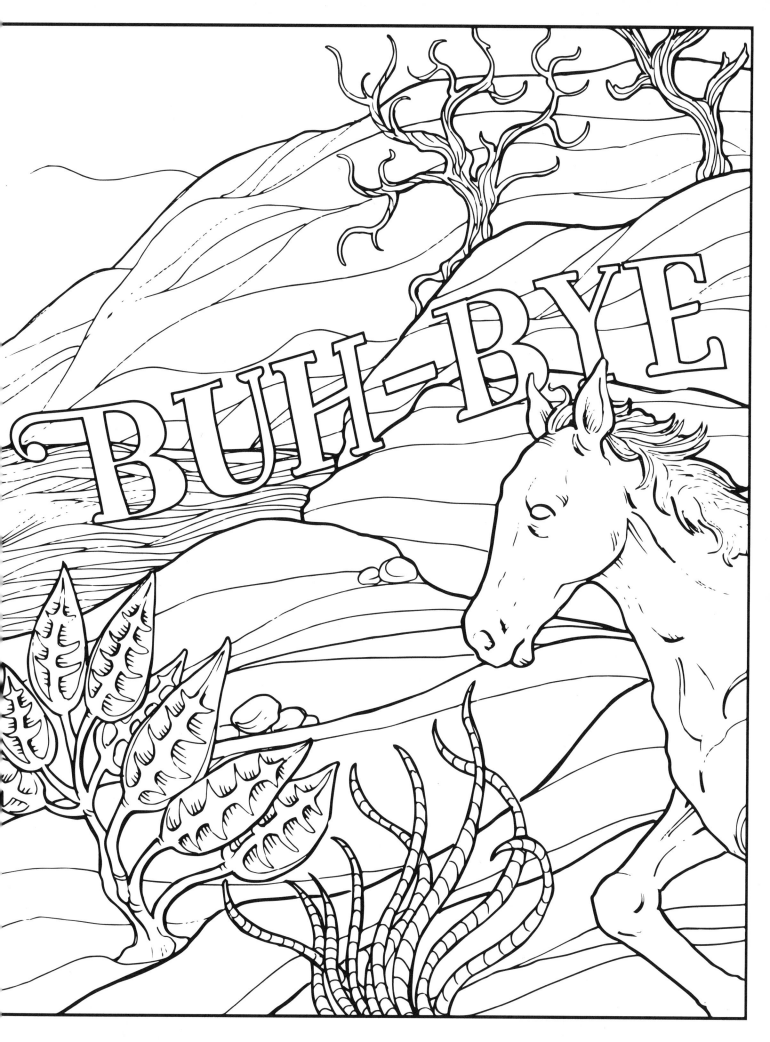

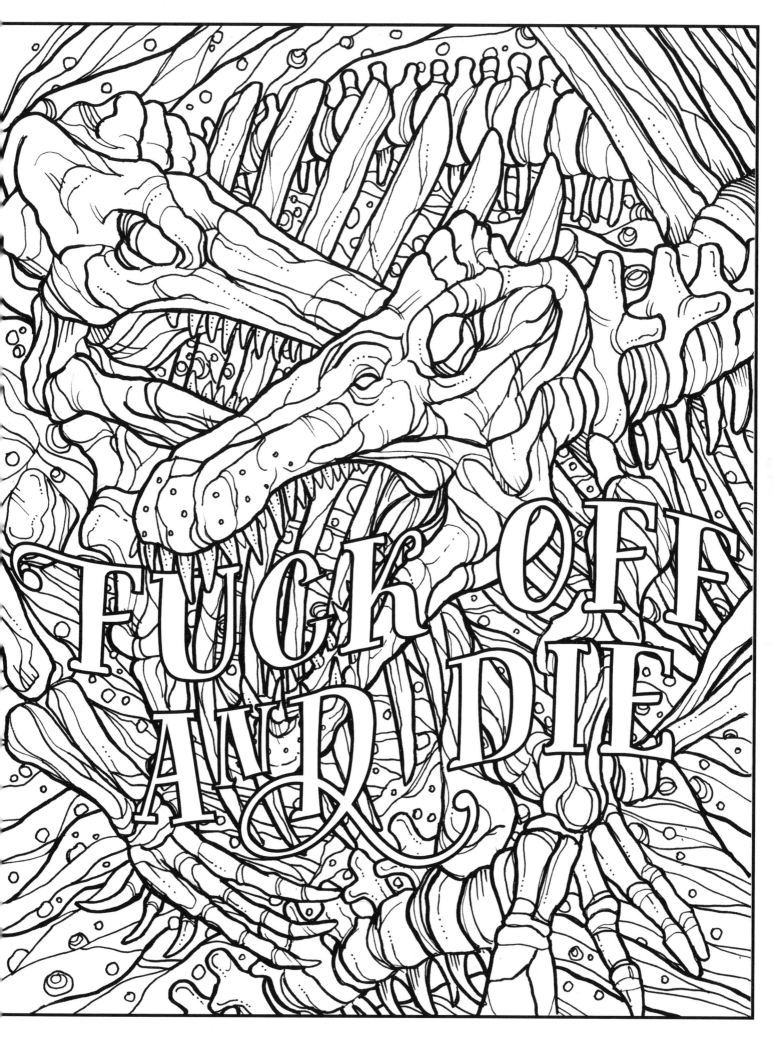

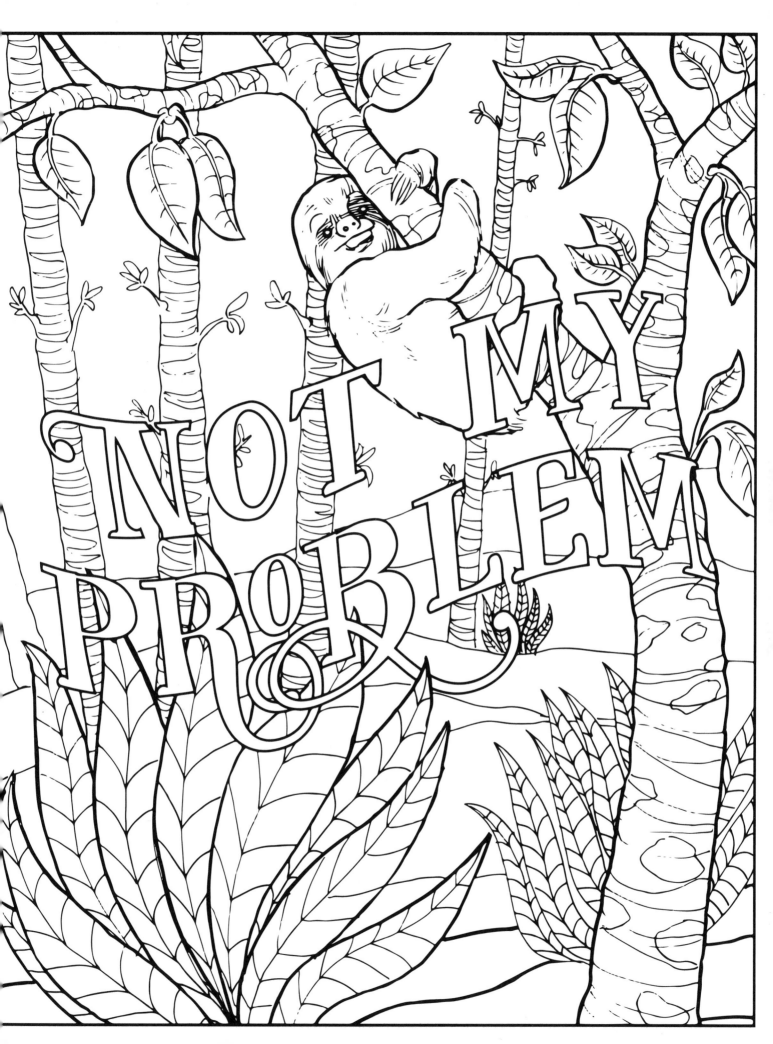

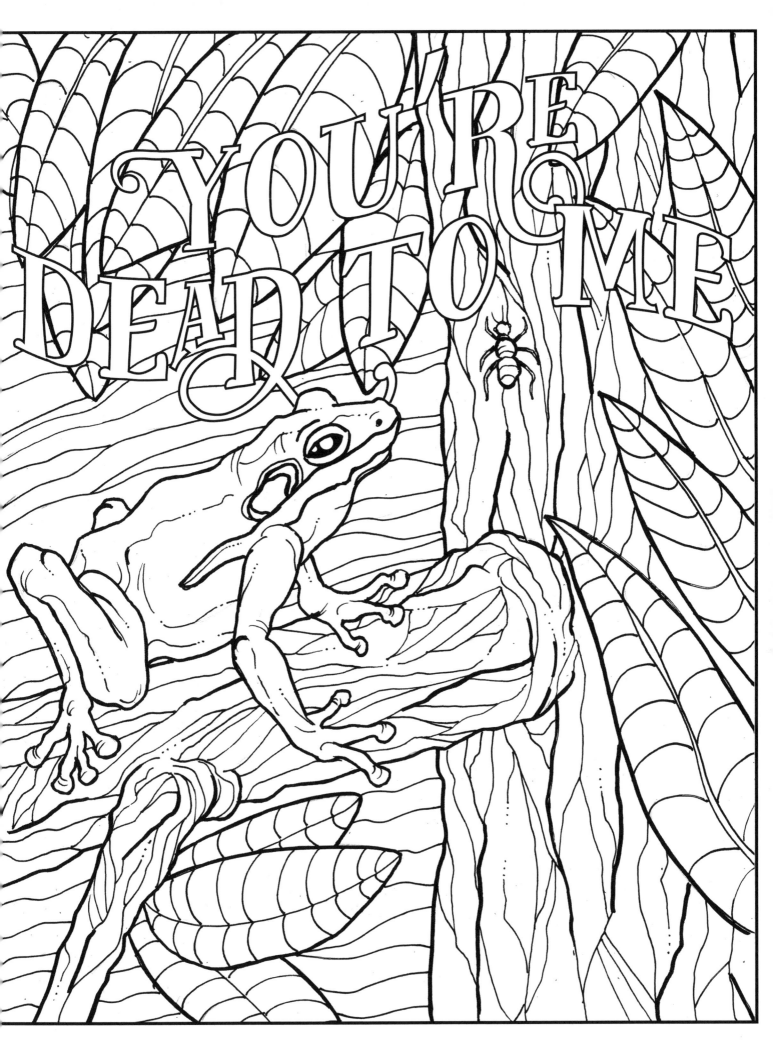

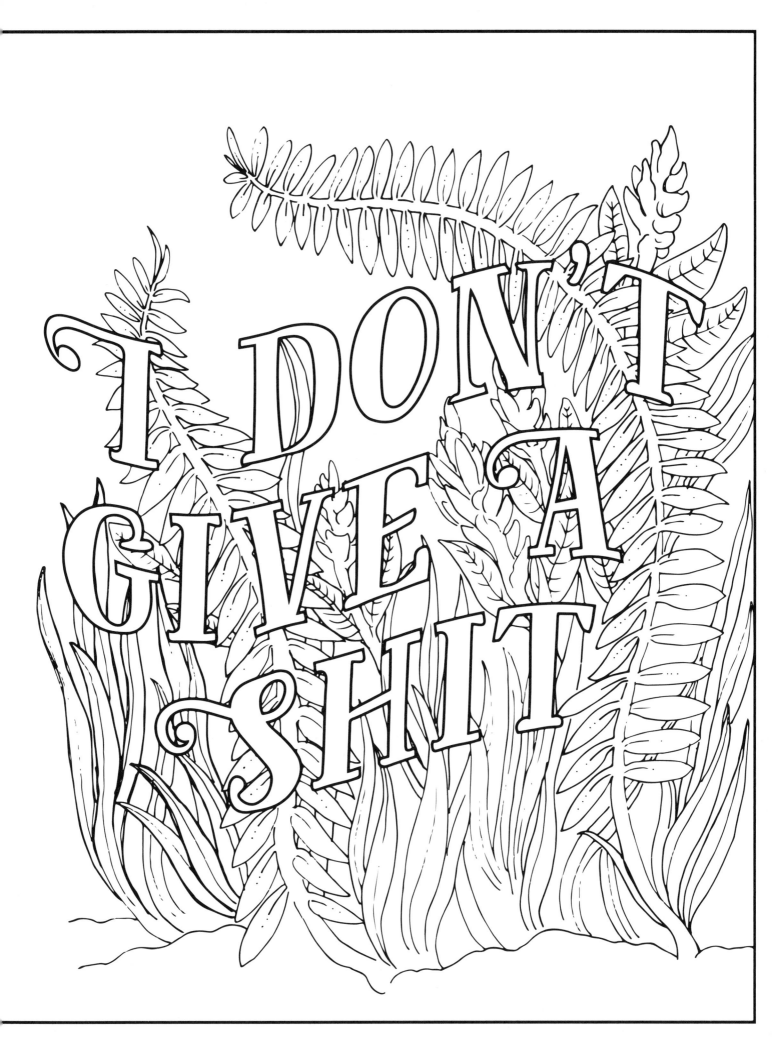

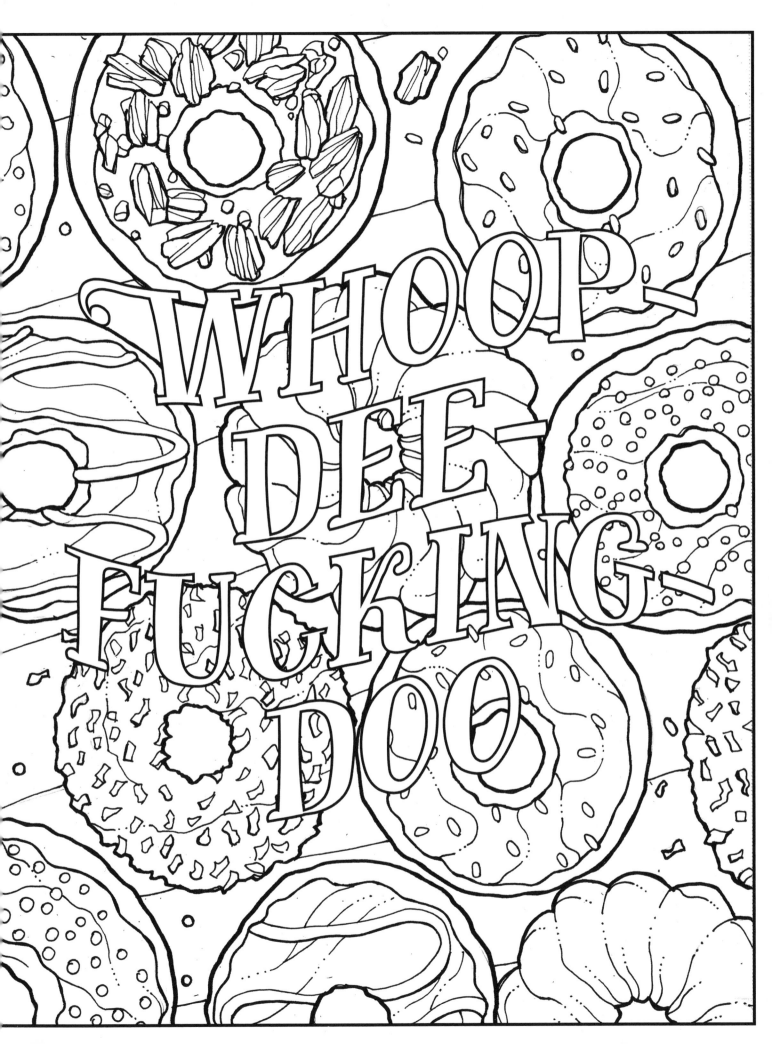

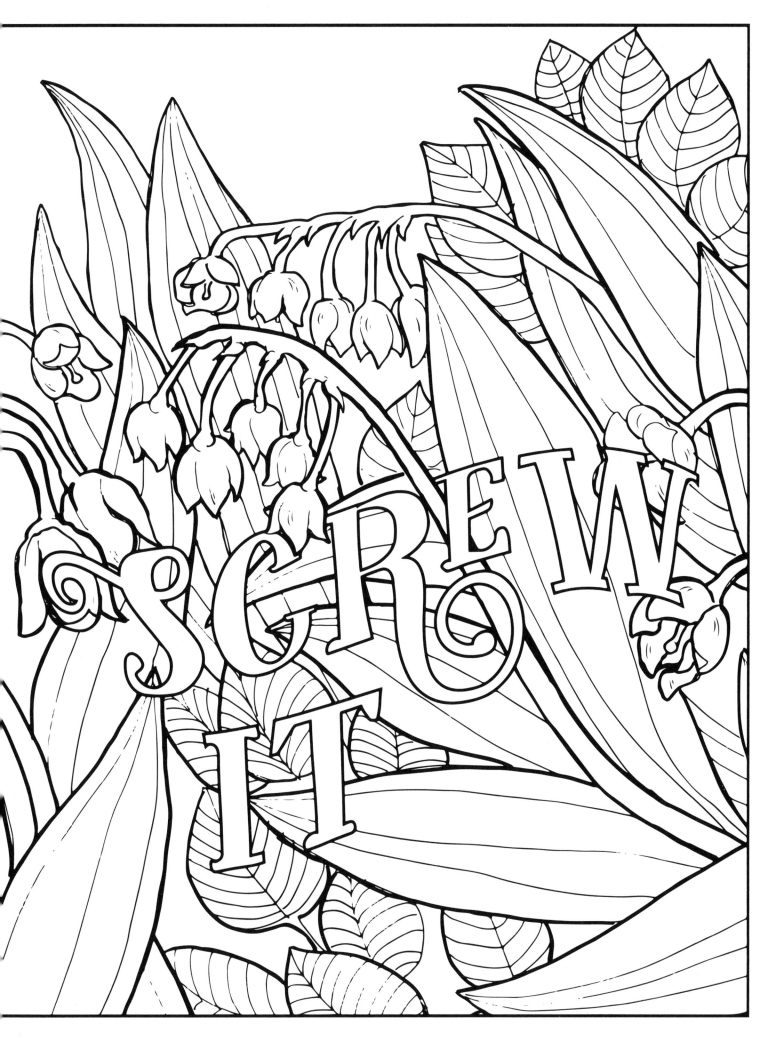

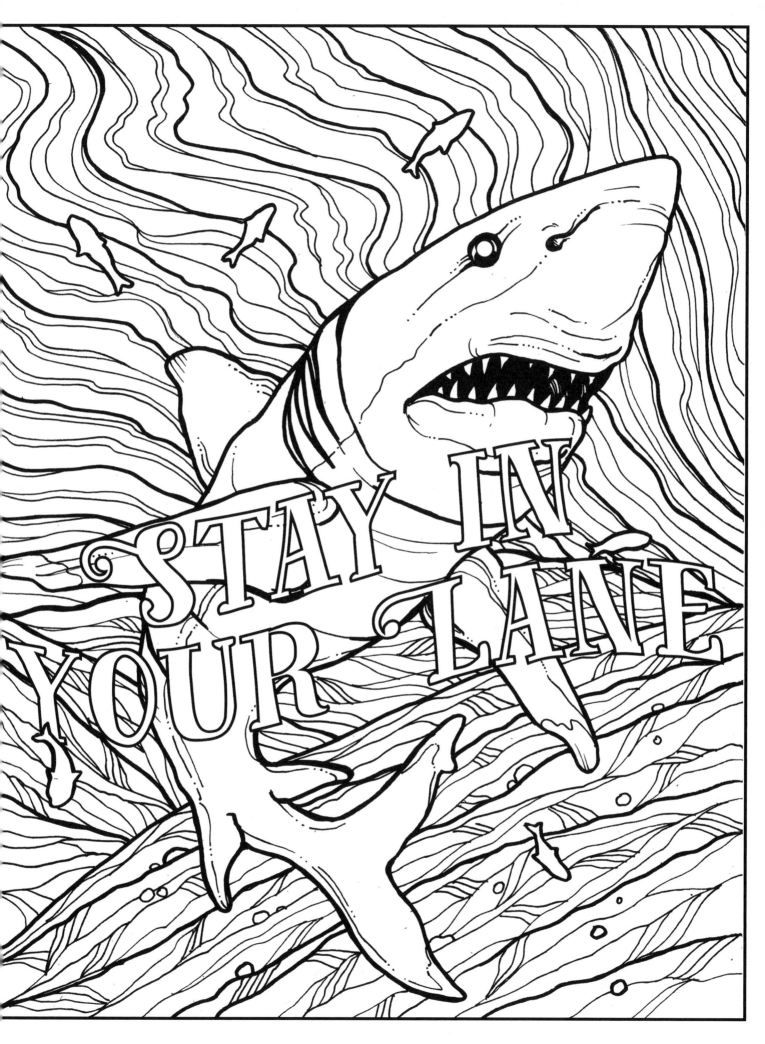

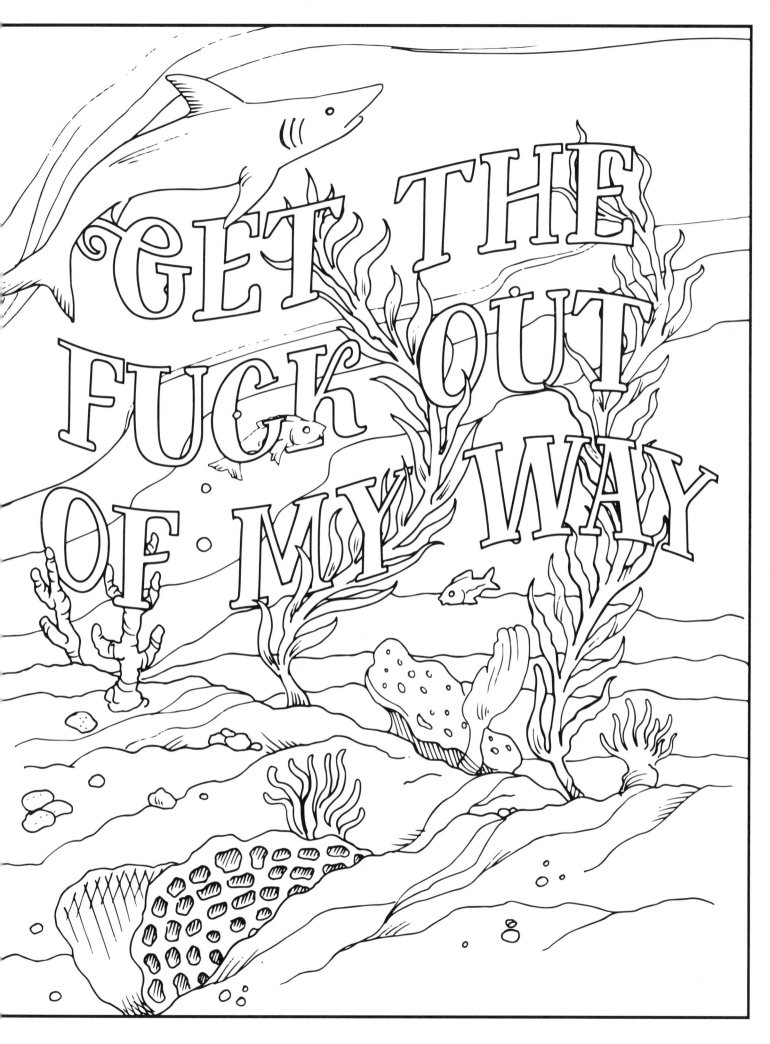

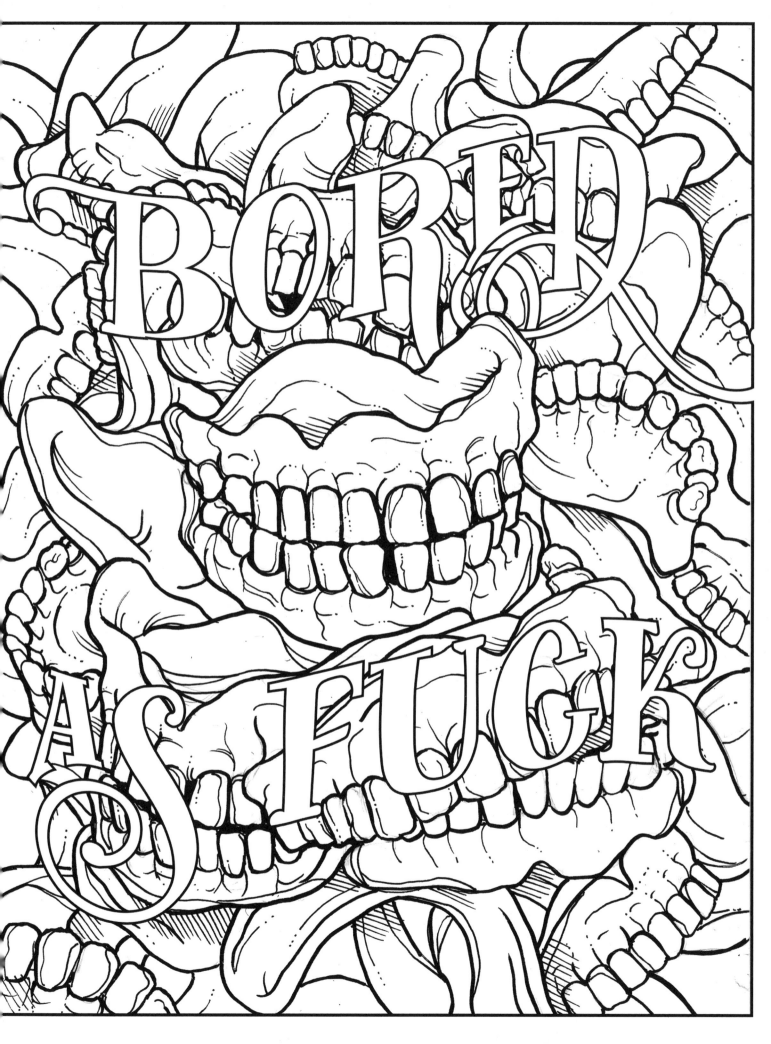

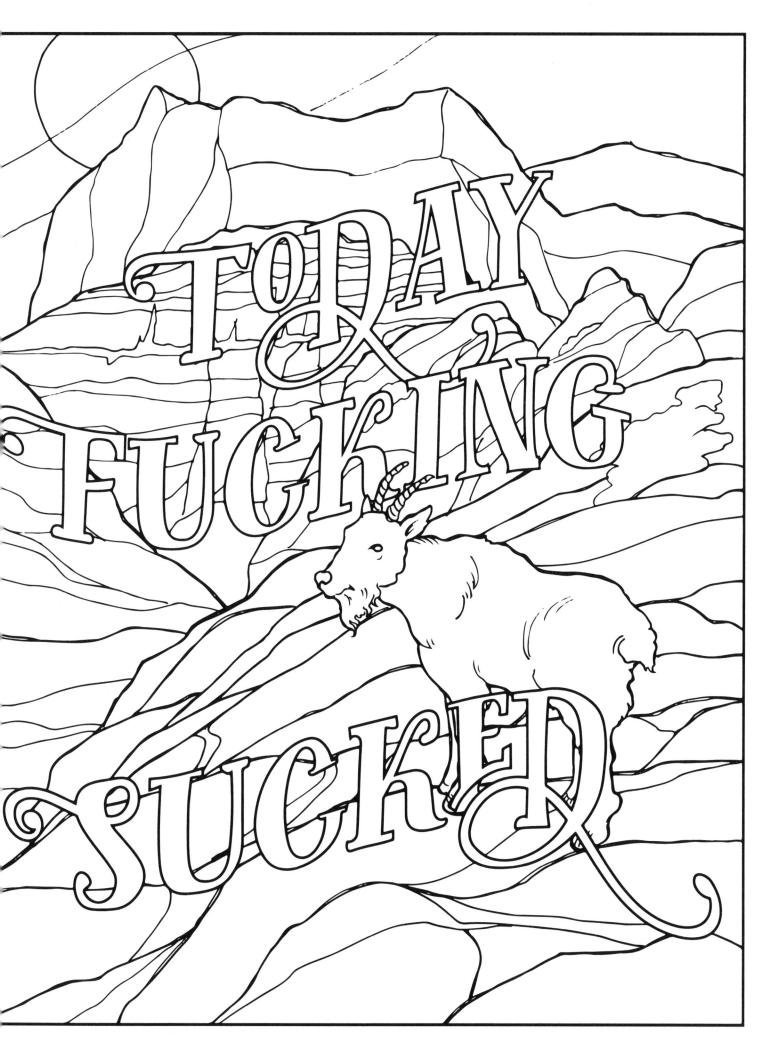

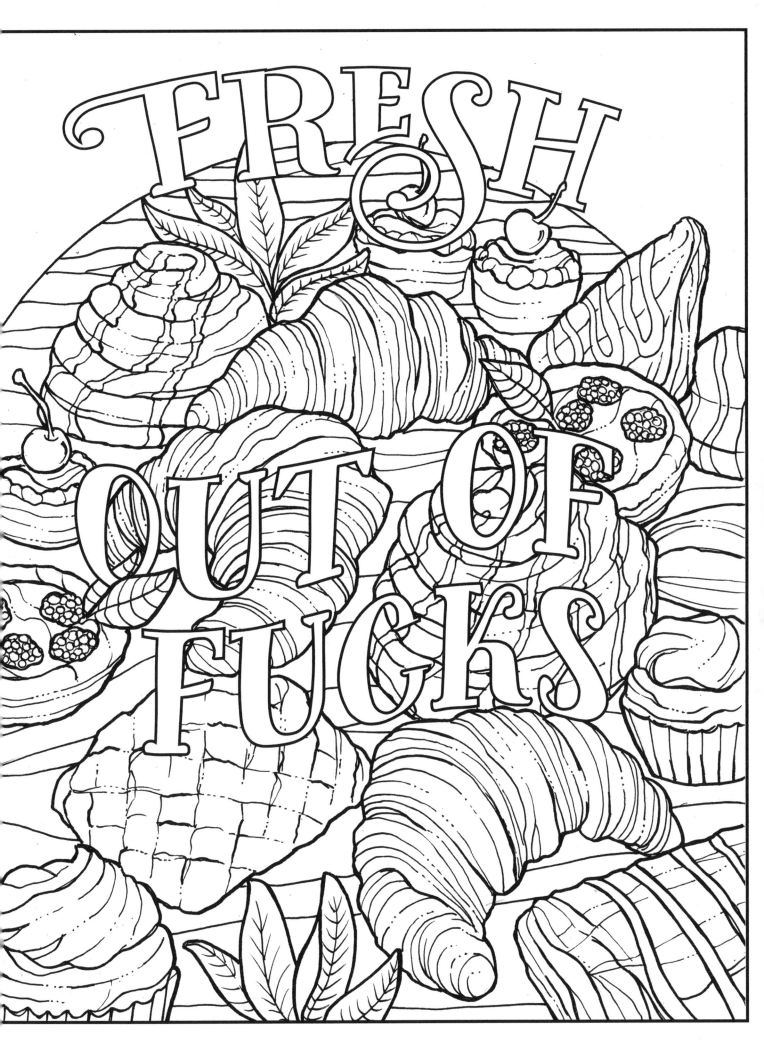

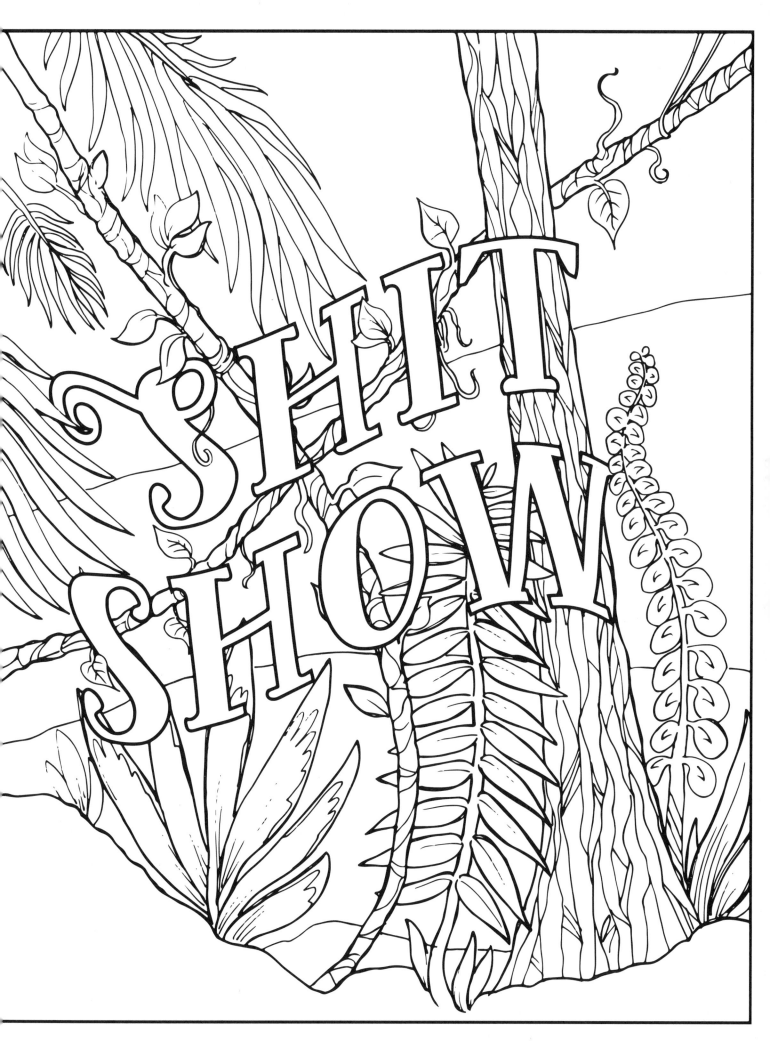

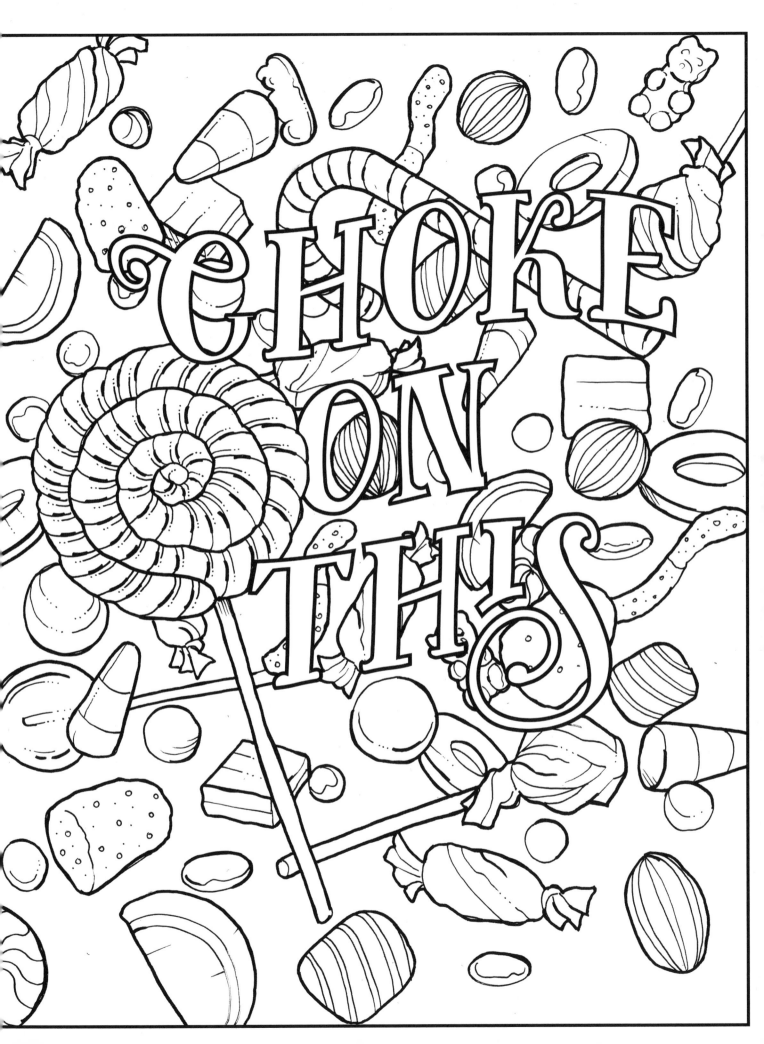

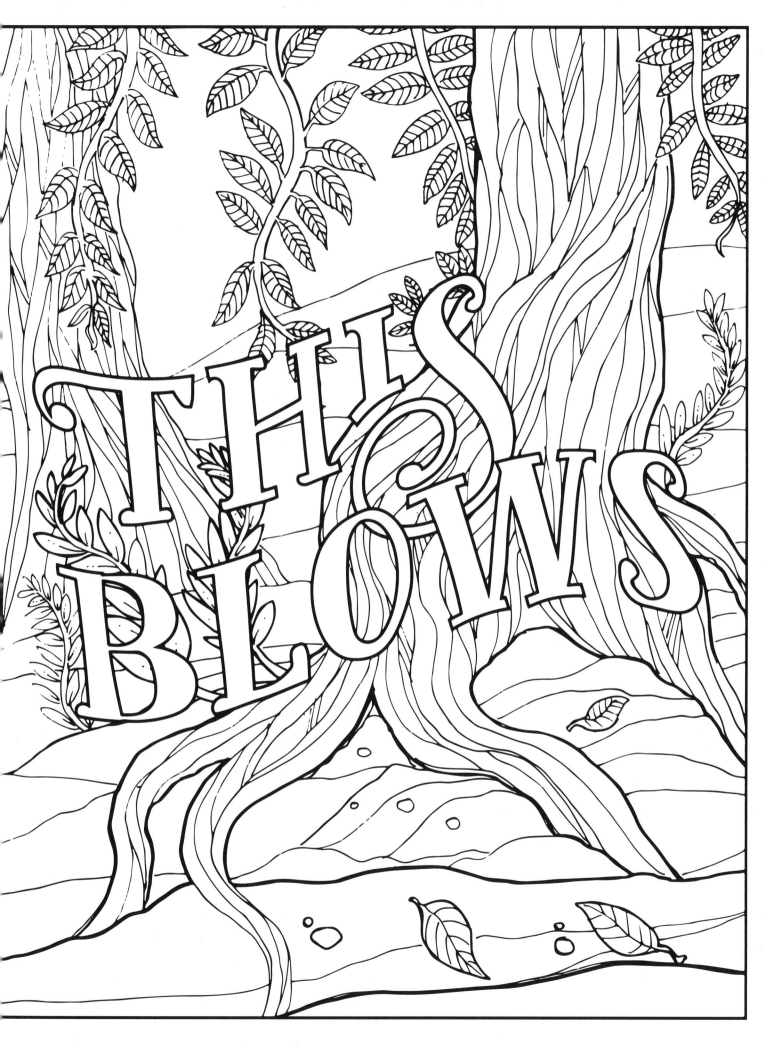

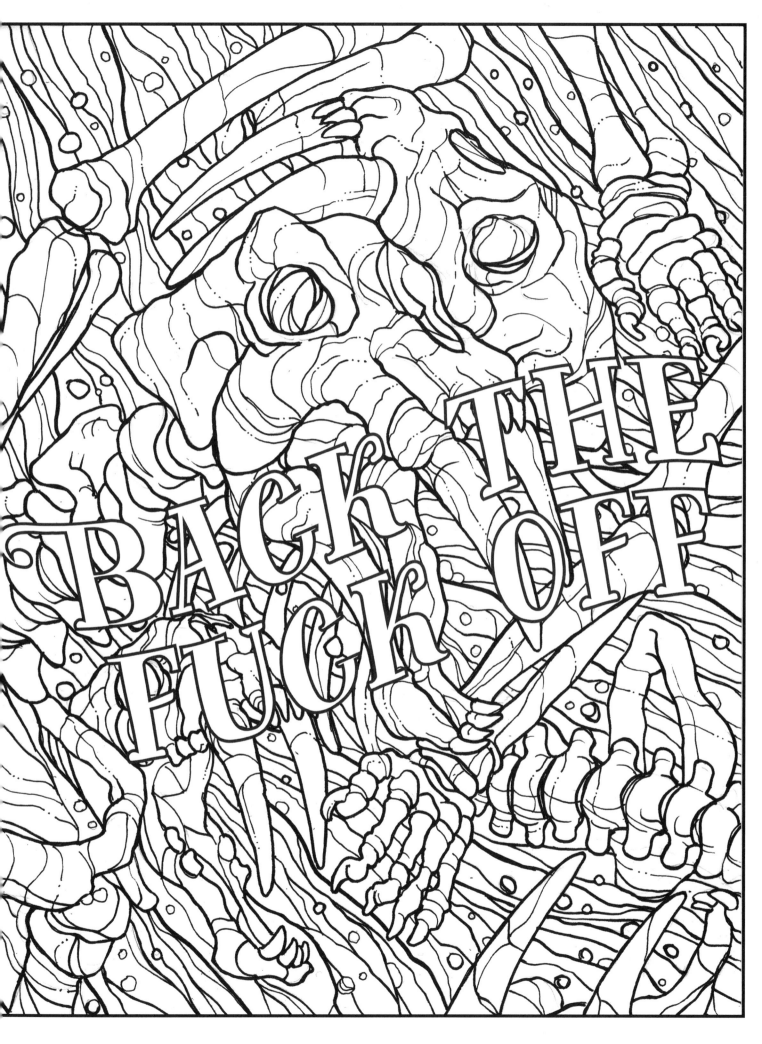

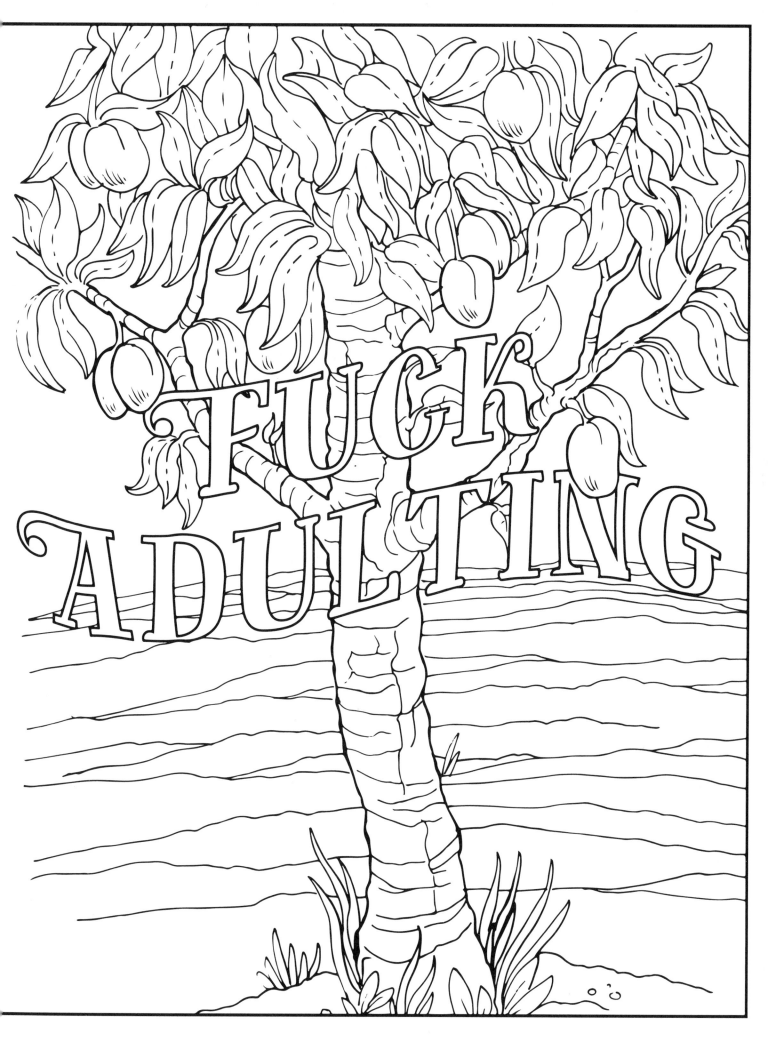

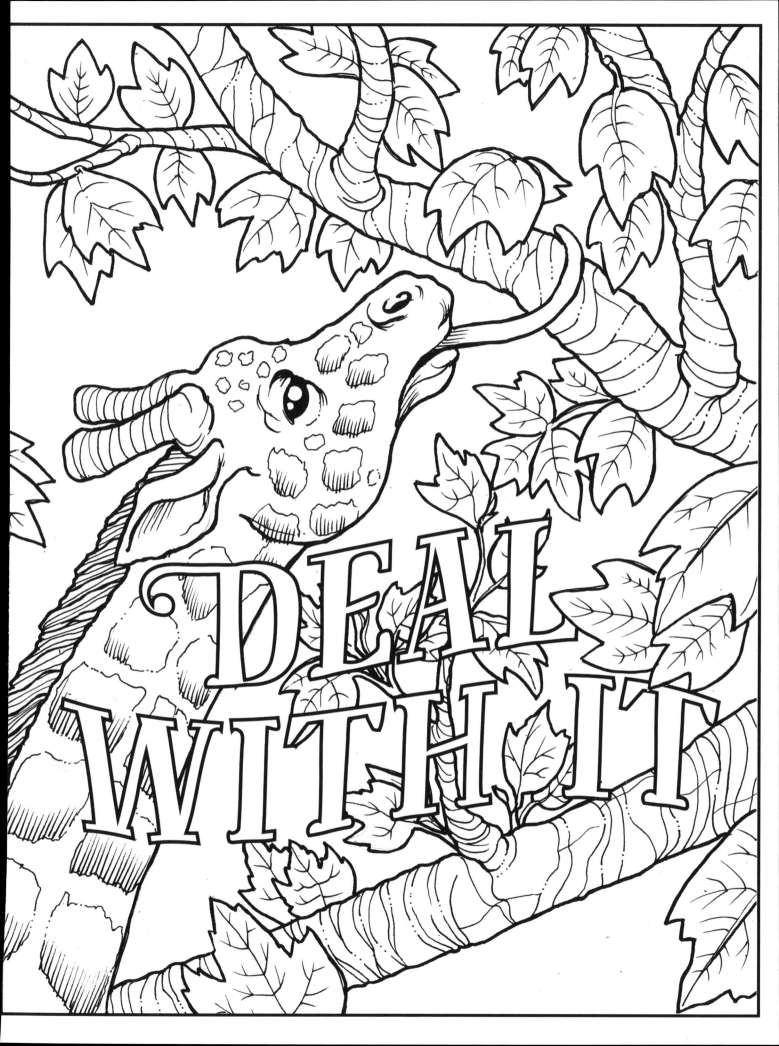

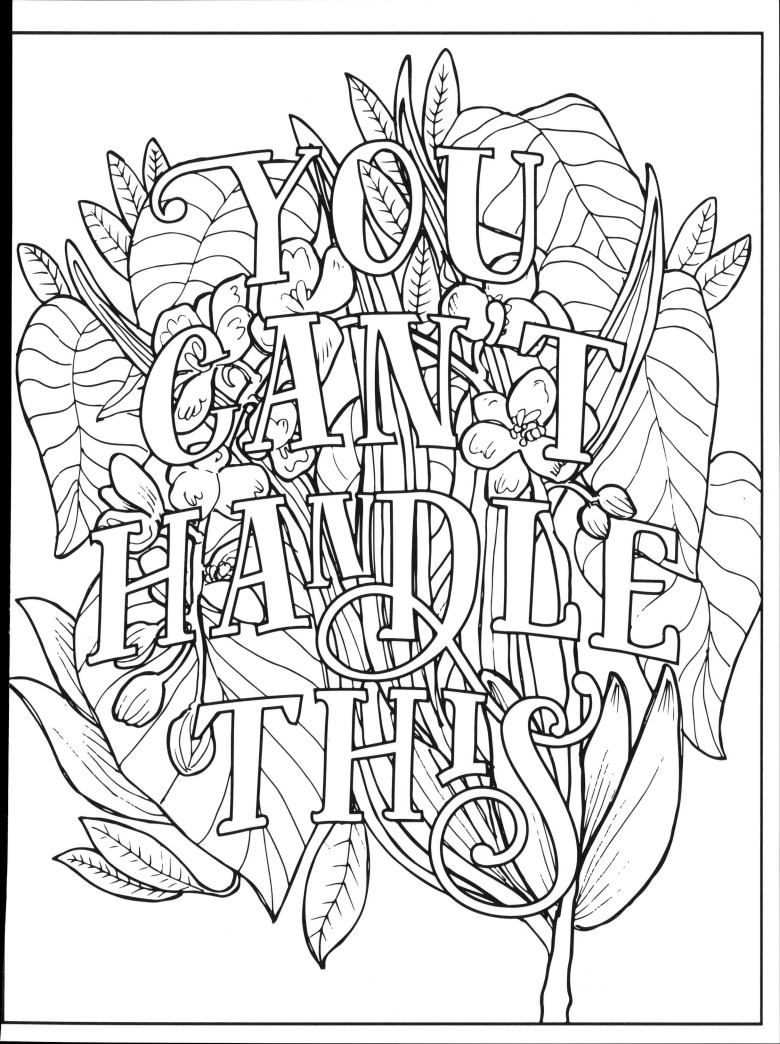

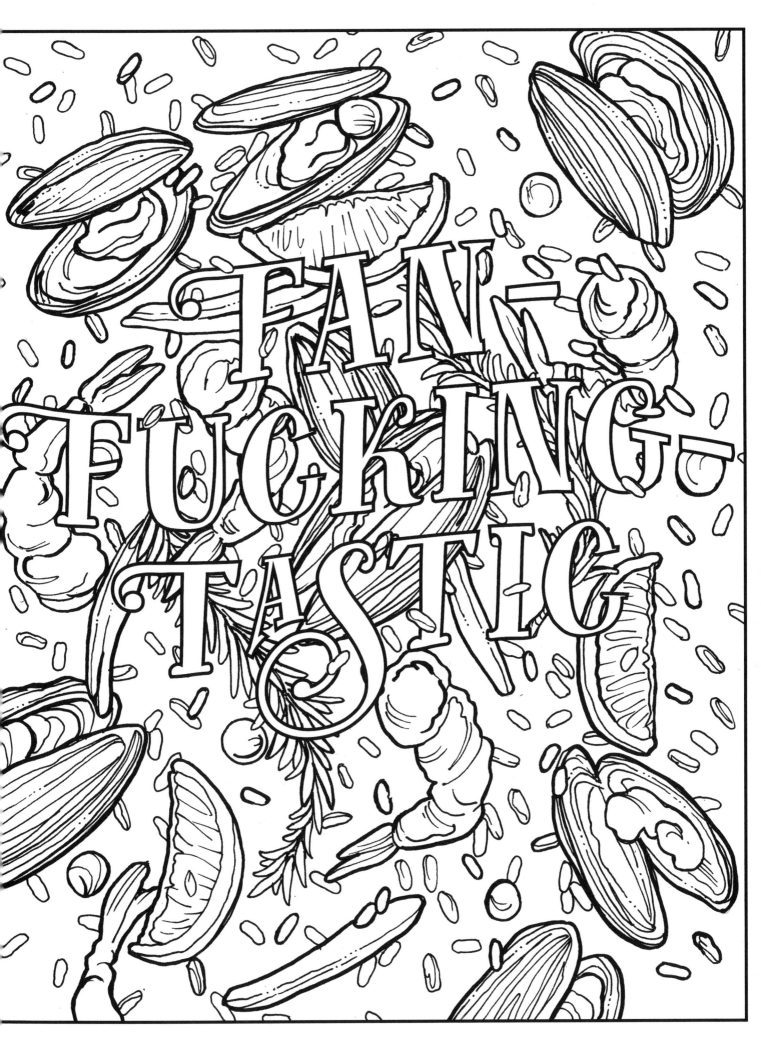

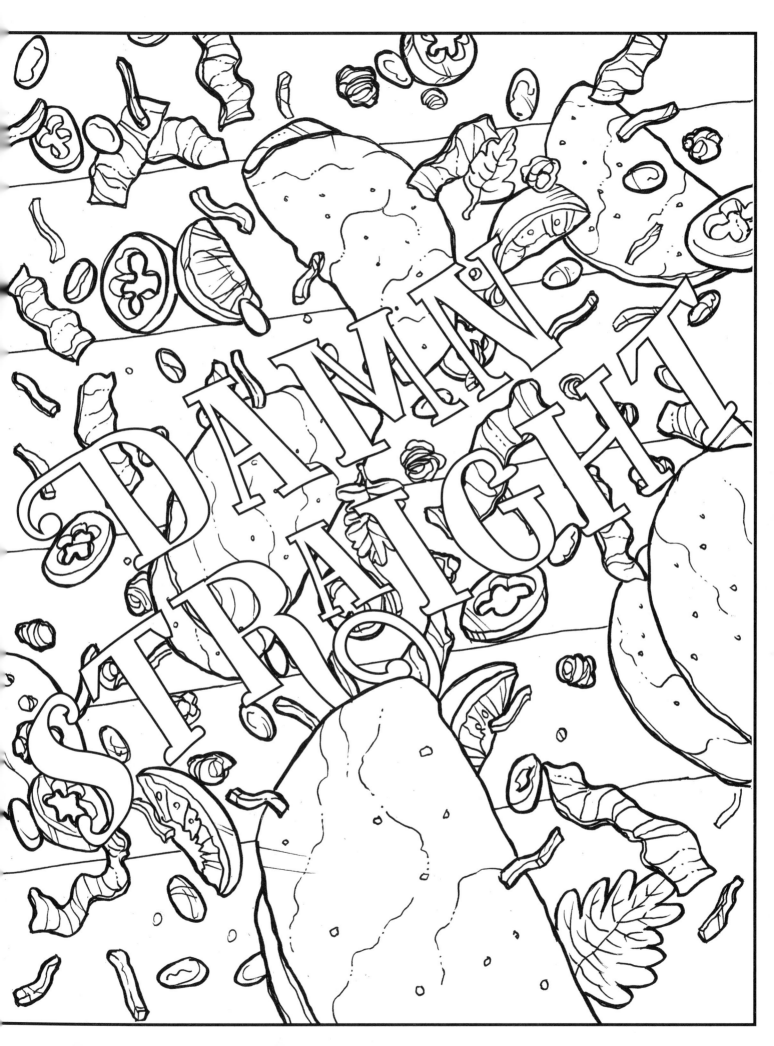

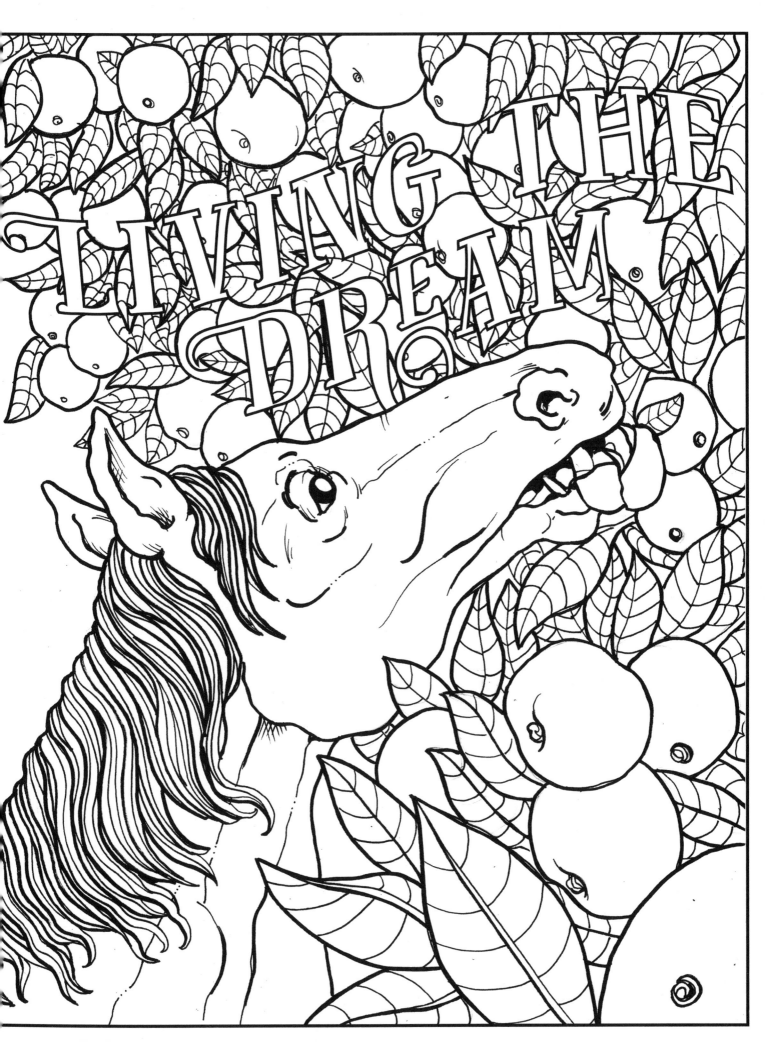

#FUCKOFFIMCOLORING #FUCKOFFIMCOLORING
#FUCKOFFIMCOLORING #FUCKOFFIMCOLORING
#FUCKOFFIMCOLORING #FUCKOFFIMCOLORING
#FUCKOFFIMCOLORING #FUCKOFFIMCOLORING
#FUCKOFFIMCOLORING #FUCKOFFIMCOLORING
#FUCKOFFIMCOLORING #FUCKOFFIMCOLORING
#FUCKOFFIMCOLORING #FUCKOFFIMCOLORING
#FUCKOFFIMCOLORING #FUCKOFFIMCOLORING
#FUCKOFFIMCOLORING #FUCKOFFIMCOLORING
#FUCKOFFIMCOLORING #FUCKOFFIMCOLORING
#FUCKOFFIMCOLORING #FUCKOFFIMCOLORING
#FUCKOFFIMCOLORING #FUCKOFFIMCOLORING
#FUCKOFFIMCOLORING #FUCKOFFIMCOLORING
#FUCKOFFIMCOLORING #FUCKOFFIMCOLORING
#FUCKOFFIMCOLORING #FUCKOFFIMCOLORING
#FUCKOFFIMCOLORING #FUCKOFFIMCOLORING
#FUCKOFFIMCOLORING #FUCKOFFIMCOLORING
#FUCKOFFIMCOLORING #FUCKOFFIMCOLORING
#FUCKOFFIMCOLORING #FUCKOFFIMCOLORING